POSTCARD HISTORY SERIES

Central Kentucky

BULLITT, MARION, NELSON, SPENCER, AND WASHINGTON COUNTIES

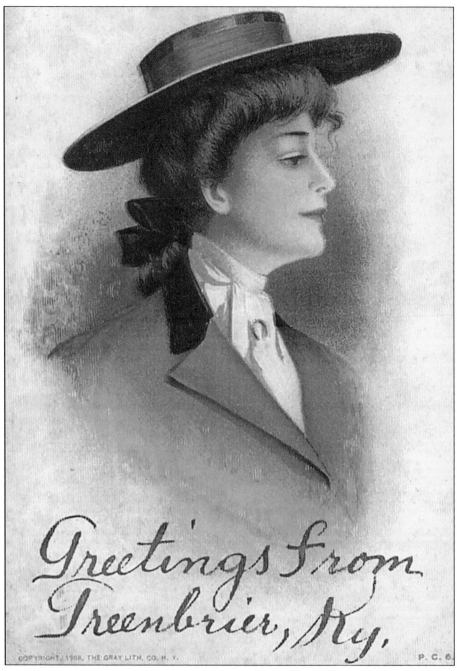

GREETINGS FROM GREENBRIER, 1909. Artists' conceptions of beautiful women in stylish attire frequently appeared on postcards in the early 1900s. This example of such a postcard portrays a winsome Kentucky belle and was mailed from the small Nelson County community of Greenbrier in 1909. On the back of the card, the sender wrote the following message to his daughter, who resided in Louisville: "Dear Lill, Bill Squires killed his goat and we have been living high. Roast goat. Fried goat. Stewed goat. And last night we had Billy goat hash and pole cat mash. We are all well this morning. Papa."

POSTCARD HISTORY SERIES

Central Kentucky
BULLITT, MARION, NELSON, SPENCER, AND WASHINGTON COUNTIES

Dixie Hibbs and Carl Howell

ARCADIA
PUBLISHING

Published by Arcadia Publishing
Charleston, South Carolina

Printed in the United States of America

Library of Congress Catalog Card Number: 99-63433

For all general information contact Arcadia Publishing at:
Telephone 843-853-2070
Fax 843-853-0044
E-Mail sales@arcadiapublishing.com
For customer service and orders:
Toll-Free 1-888-313-2665

Visit us on the Internet at www.arcadiapublishing.com

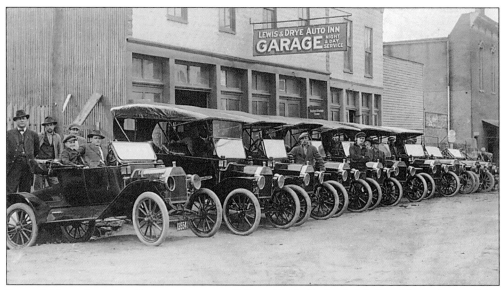

Lewis & Drye Auto Inn Garage, Lebanon, KY, c. 1913. Parked side-by-side in front of the Lewis & Drye Auto Inn Garage on Proctor Knott Avenue between Main and Mulberry Streets in Lebanon, are ten new 1913 Ford Model T automobiles. Prospective purchasers are either standing beside or sitting inside the Model T of their choice as they pose for the camera of Lebanon photographer J.W. Miller. Lewis & Drye became the agent in Marion County for the sale of Ford automobiles in 1912 and opened garages in Bradfordsville and Lebanon. Offering "night and day service," they operated agencies selling automobiles and Fordson Farm Tractors. They advertise in 1912, ". . . one Lebanon Ford in 1911 made 95 miles on 3.5 gallons of gasoline; on another trip, made 163 miles on 7 gallons carrying 5 persons."

CONTENTS

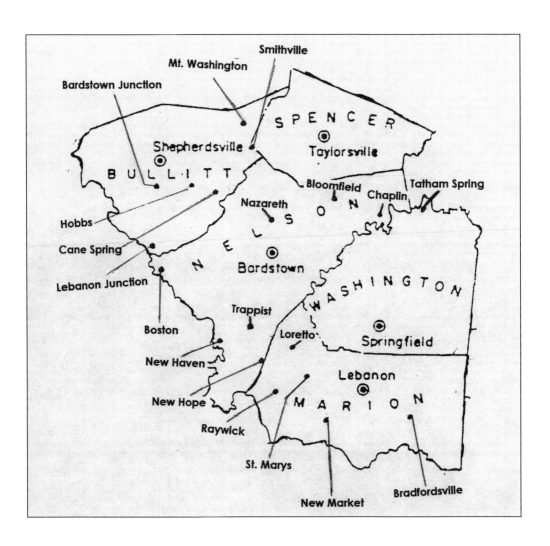

Smithville

Mt. Washington

Bardstown Junction

S P E N C E R

Shepherdsville

Taylorsville

B U L L I T T

Bloomfield

Chaplin

Tatham Spring

Hobbs

Nazareth

N E L S O N

Cane Spring

Bardstown

Lebanon Junction

W A S H I N G T O N

Trappist

Boston

Loretto

Springfield

New Haven

Lebanon

New Hope

M A R I O N

Raywick

St. Marys

Bradfordsville

New Market

INTRODUCTION

Memories often fade as we grow older and once clear recollections of people, places, and events in our early years become blurred and are eventually lost when we die. Books, magazines, and newspapers often constitute the only sources of information that historians and researchers turn to when attempting to learn about the early years of the 20th century.

Little known is the fact that often the best if not the only sources of photographic images of our country's history are picture postcards, which were literally made by the thousands during the early 1900s. Although the great majority of these "little pieces of history" were soon destroyed or discarded after they were received in the mail, many have survived to reveal people, activities, lifestyles, architecture, landmarks, and history-making events that would otherwise be forever lost to future generations. Because they portray practically every type of subject and category, certain of these old picture postcards have become documents of social and historical significance.

It is the opinion of the authors that the postcards included in this volume are among the rarest and best existing images currently available to chronicle the rich history of Bullitt, Marion, Nelson, Spencer, and Washington Counties during the first 30 years of the 20th century. In addition to drawing from their own collections of "Golden Age" postcards, the authors have gained access to and been granted the use of several postcards from private collections of people who are current or former residents of these counties.

A primary goal of the authors is to preserve and highlight for future generations much of the area's rich history that only postcard views can accurately portray. This is because many of the early picture postcards provide the only available photographic account of life during this exciting era. Consequently, the reader can now examine, for the first time, specially selected views and glean a new and refreshing perspective of the way things really were in this five-county area of central Kentucky.

The highest quality picture postcards were printed in Germany until about 1914 and the onset of World War I. One of the authors' favorite publishers is the Kraemer Art Company, which was located in Cincinnati, OH. The founder of the company, Albert Kraemer, benefited from numerous contacts with German printers and the knowledge he acquired over many years regarding the development and manufacture of beautiful hand-colored postcards. He and other publishers took great pride in maintaining high standards of excellence. Their painstaking devotion to content and detail is reflected in the clarity and beauty of their postcard scenes.

During the first decades of the 20th century, there were many out-of-state photographers who traveled throughout the Commonwealth. They, like Albert Kraemer, would seek to photograph, often for the first time, a new school, firehouse, general store, or other local landmark. These photographic images were printed as postcards, sold in drug stores and

other business establishments, and then mailed across the country to relatives, friends, and other acquaintances.

In addition to printed postcards, certain black-and-white images now known and classified by collectors as "real photo" postcards provide some of the rarest and most historically accurate views available. These postcards are actual photographs with a postcard back. They were developed from negatives directly on photo printing paper with "postcard" printed on the back of the card.

The postcard soon proved to be the best and most popular means of fast, easy, and informative communication. In many instances, a postcard view is the only pictorial record that exists by which we can learn of a subject or area. As there was no television from 1900 to 1930, the picture postcard provided the best and most popular way to both illustrate and provide information about the special places, people, and events that were most meaningful to an area's residents. Many of the beautiful hand-colored 3.5-by-5.5-inch postcards produced during this period are today considered by the growing number of collectors throughout the world as miniature works of art.

The assemblage of selected postcard views contained in this volume showcases a fascinating and important era in Kentucky's history. Presented here are rare glimpses of churches, schools, hotels, resorts, parks, stores, and distilleries that no longer exist. The people themselves are revealed at work and at various community events. A selection of imaginative and nostalgic images are combined with text that is both accurate and informative. From horses, buggies, stagecoaches, and trains to the first automobiles, the evolution of transportation in this area is portrayed in vivid detail. The reader can experience the excitement and atmosphere of a celebration, sporting event, Chautauqua, or county fair as it actually occurred in a more relaxed and patriotic time.

The important railroad history of these five counties has one company in common—the Louisville & Nashville Railroad. During the early 1900s, many businesses in the towns and communities within these counties depended greatly on the arrival of L&N passenger and freight trains to local depots. Consequently, we have attempted to include both images and historical data that will serve to highlight scenes from this area's railroad history when rail travel was commonplace.

We have sifted through, analyzed, and summarized reams of historical background information and interviewed numerous local residents and historians to provide the text for the postcard illustrations contained in this volume. We hope that whether you merely peruse it as a regional book with some interesting old pictures in it or consult it as a relevant historical resource, this book will lift you up, slow you down, and pique your interest. In the final analysis, our primary wish is that the legacy left to us by our forefathers will be rekindled and that the fascinating history of this period, together with much of the area's rural beauty and tranquillity, will be promoted by this book and preserved for future generations.

One

BULLITT COUNTY

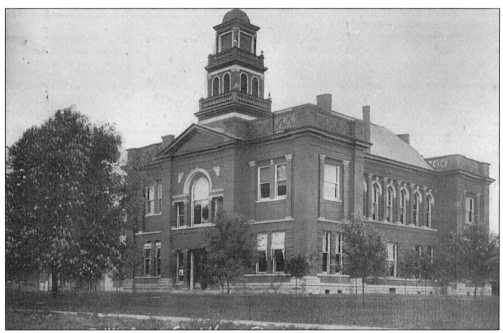

BULLITT COUNTY COURT HOUSE, MAIN STREET, c. 1910. Bullitt County was formed in 1796 from parts of Jefferson and Nelson Counties and named for Alexander Scott Bullitt, Kentucky's first lieutenant governor. Shepherdsville is the county seat. The courthouse features Beaux Arts details and was built in 1900. Discussions concerning the replacement of the old courthouse in the square at Second and Main Streets were held as early as the 1870s. Court Day and Election Day were always special occasions. Many people came to spend the day in town, to shop, and to trade mules and horses, as well as all manner of farm and household items.

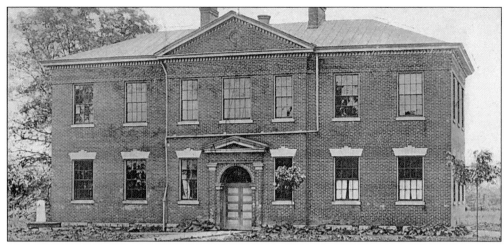

BULLITT COUNTY GRADED AND HIGH SCHOOL BUILDING EAST OF RAILROAD ON SECOND STREET, *c.* **1915.** This building of four classrooms and two halls was constructed in 1913. Principal J.H. Sanders enlarged and improved it to have eight classrooms, three halls, an office, electric lights, heating plant, lab, and a library. By 1918, it had a four-year high school and a gym. A 1925 student recounts her memories of the school, "The teachers moved from class to class instead of the students. The sanitary facilities were built a short distance behind the school. The teachers had a 'two holer' and the girls a '3 holer.' " A new high school was built in 1938 and this one was dismantled in 1981.

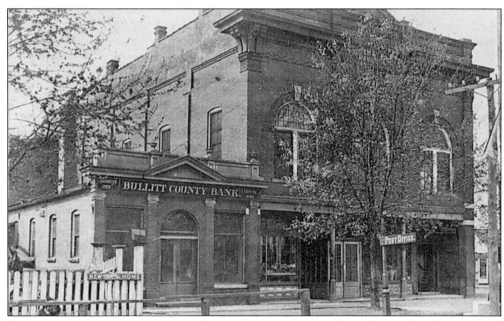

TROUTMAN BROS. "MAMMOTH STORE" SHEPHERDSVILLE, **KY,** *c.* **1910.** The Bullitt County Bank was organized about 1889. Earlier, the Troutman brothers carried on a deposits and checking business in their store in the next-door building. The Shepherdsville Post Office was inside the store. A post office sign, a little boy leaning on a hitching rail, and mounting blocks can be seen. This building was located on the southeast corner of Second and Main Streets.

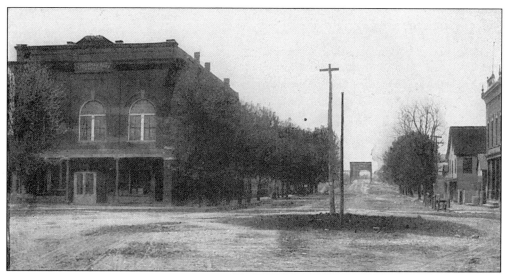

MAIN STREET LOOKING SOUTH, SHEPHERDSVILLE, KY, *c.* **1911.** An iron bridge over Salt River is at center. The building at left is Troutmans' Mammoth Department Store, which advertised that it carried everything from caskets to clothing. An undertaking and embalming business was located on the second floor. This building burned in 1927. Not visible on the right side, but located on the opposite corner, was the American Hotel operated by William McGrew. The brick two-story building at far right is the Maraman Brothers general store. Half a block down the street is the 1818 stone bank building.

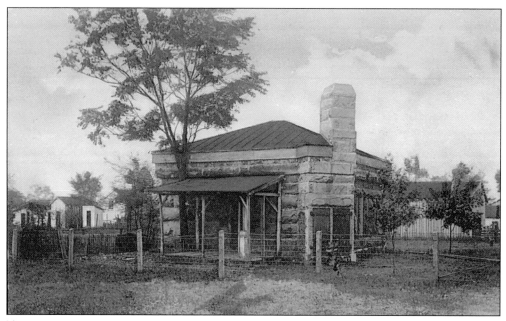

THE BULLITT CO. JAIL, SHEPHERDSVILLE, KY, *c.* **1909.** The Bullitt County Jail was built in 1891 by McDonald Bros. of Louisville at a cost of $4,000. The new courthouse was constructed in 1900 directly in front of this building. In 1911 news articles, prisoners were said to go to the "rock mansion." The fence around the jail allowed prisoners an opportunity to exercise. Some accounts reflect that they could get their hair cut while leaning over the fence.

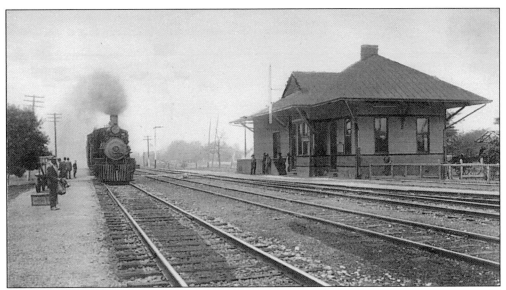

L&N Depot, Shepherdsville, KY, *c.* **1909.** The worst train wreck in the L&N Railroad's history occurred just past this station on December 20, 1917. The daily "accommodation," a commuter train from Louisville full of Christmas shoppers from Nelson and Washington Counties, was backing into the siding track to allow the express to run by when it was struck from the rear. The express from Cincinnati was late and trying to make up time. The fault was determined to be divided between the engineer of the fast train and the conductor of the commuter train. The wooden passenger cars were crushed and derailed. Forty-seven people were killed instantly. Ten more died later. Many others were seriously injured.

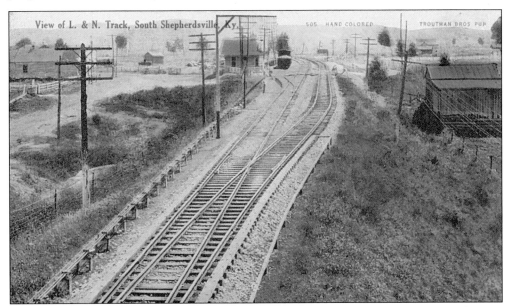

L&N Tracks, South Shepherdsville, KY, *c.* **1909.** The top center building is the Salt River Station located about one mile from the Shepherdsville Depot. This view is of the tracks directly after crossing the bridge over Salt River. The single track over the bridge branches back into the double tracks, which are on both sides of the bridge.

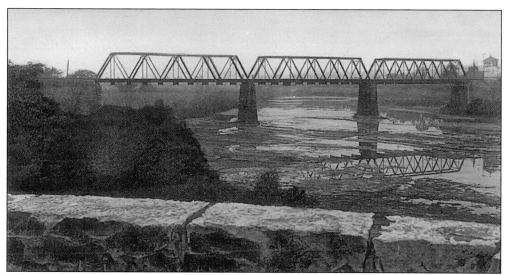

L&N Bridge over the Salt River, *c.* **1908.** The first L&N Railroad Bridge over Salt River was built when the railroad was extended south from Louisville to Nashville in 1855. This bridge was destroyed by Confederate troops with General Braxton Bragg's army in September 28, 1862, when they occupied the area. Union engineers repaired and opened the bridge for use by October 11, 1862. These army engineers were directed to repair or replace all the destroyed bridges on the L&N lines, with the company repaying them later. The signal tower on the right was used to signal trains to wait when another train had to cross the bridge on the single track. The bridge in this image was replaced in 1912 by a double track bridge.

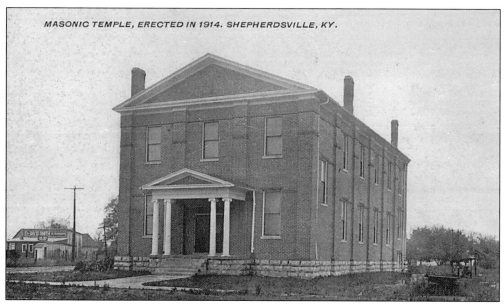

MASONIC TEMPLE, ERECTED IN 1914. SHEPHERDSVILLE, KY.

Masonic Temple, *c.* **1920.** Construction plans were made several years before the erection of this temple at the corner of Fourth and Main Streets in Shepherdsville. The lodge building was dismantled in 1997. On the building at left, a sign notes: "Dr. David Smith, Veterinarian's office."

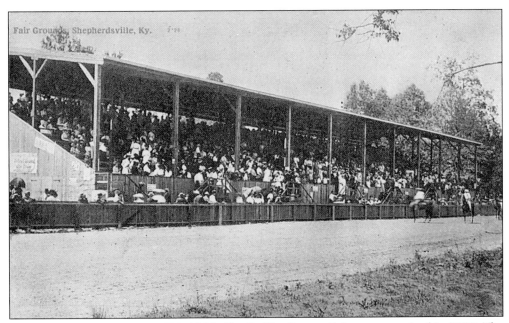

FAIRGROUNDS, SHEPHERDSVILLE, KY, 1909. The Bullitt County Fair was organized in 1895. The fairgrounds were located one mile north of the post office on Preston Street Pike. In 1908, a new grandstand seating 4,000 people was erected to replace one that had burned. An advertisement proclaimed, "six to eight thousand could be accommodated." The 1912 fair pamphlet noted that no gambling was allowed at the fair. It was a four-day fair with saddle and harness races, animal shows, and all types of agricultural exhibits. There were also cattle pens, stables, poultry sheds for animals, and two concession buildings, one with a lunch stand and the other for the sale of soft drinks.

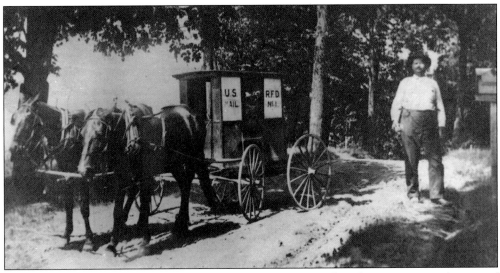

MAILMAN GEORGE H. BRADBURY, C. 1915. In the early years of mail service to rural areas of Bullitt County, George H. Bradbury delivered mail on RFD route No. 1 from Belmont to Pitts Point. Now in the Ft. Knox military reservation, Pitts Point was located at the confluence of the Salt and Rolling Fork Rivers.

14

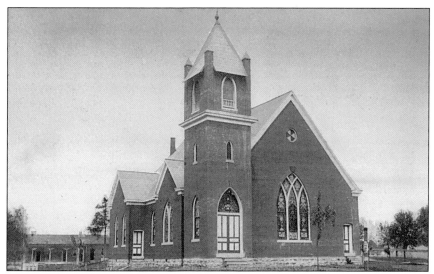

DAVIDSON M.E. CHURCH, SHEPHERDSVILLE, KY, c. 1909. This Methodist-Episcopal church was located on the northwest corner of Third and Main Streets. Organized in 1843, the first Methodist church, a frame structure, was utilized until the present building was erected in 1906–1907. The old church was moved across the street and used as a residence until it was later torn down. The dedication of the church was a big event that lasted the entire day. In 1911, a public, fund-raising musical was given at the church for the benefit of both Catholic and Methodist churches.

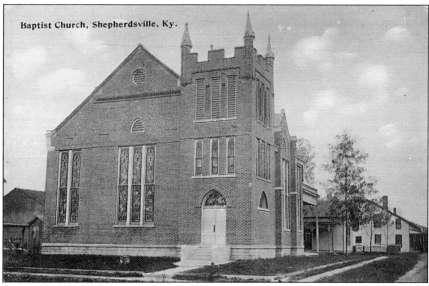

BAPTIST CHURCH, SHEPHERDSVILLE, KY, c. 1912. Organized in 1837, the Baptist church was located across Main Street from the Methodist church. After the Civil War ended, the membership of this church almost completely vanished and the original church sat empty for several years. The congregation grew from 63 members in 1903 to 305 members in 1911. The cornerstone of this building was laid in 1910 under the leadership of Dr. Sam P. Martin. The stained-glass windows of this church were taken from the older church. The church was dismantled in 1973.

15

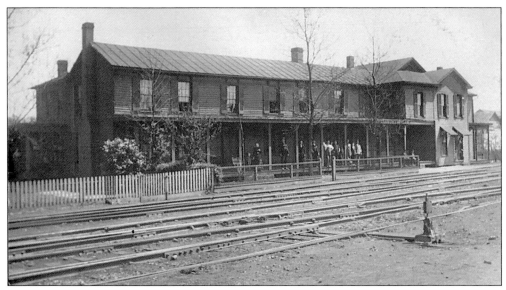

HOCKER HOTEL, LEBANON JUNCTION, KY, c. 1910. Lebanon Junction was selected as a site for a rail yard and a roundhouse for steam locomotives in the mid-1850s when the railroad was built from Louisville to Nashville. This was the first branch off the main line and went to Lebanon. The L&N Railroad built the Hocker Hotel alongside the Lebanon track to provide housing for its workers. A barbershop was on the first floor on the right. On November 2, 1912, an acetylene plant used in lighting the 40-room hotel exploded causing a fire that destroyed the building. At that time, S.K. Clark owned and operated the hotel. It was uninsured and the loss was estimated to be $20,000.

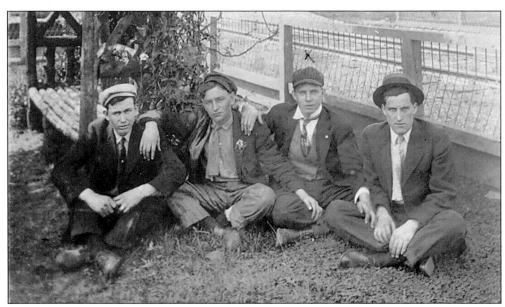

HANGING AROUND THE LEBANON JUNCTION DEPOT, 1910. A small fenced and landscaped plot behind the depot provided a pleasant place to wait for the train. Behind these young men are a rustic bench and trellis. The first man on the left is unknown. The others, from left to right, are Bud Masden, Ben Charlton and Chris Skaggs.

16

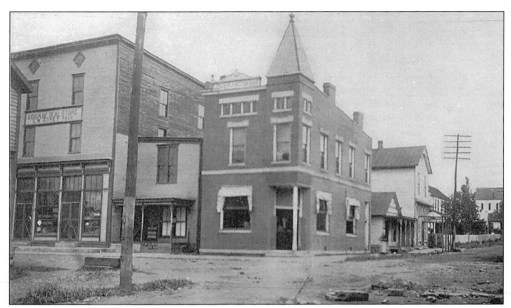

MAIN STREET, LEBANON JUNCTION, KY, c. 1910. The large frame building on the left is the G.W. Roney "Square Deal Store" of general merchandise between Main and Oak Streets. On the corner is the Lebanon Junction Bank, built in 1901, four years after it was organized. The small building between them is a millinery shop. Down the street from the bank is a two-story white frame building. The post office occupied the first floor of this building and Dr. T.P. Sloan had his dentist office on the second. At right on the hill is the Methodist church, which was dismantled by 1923.

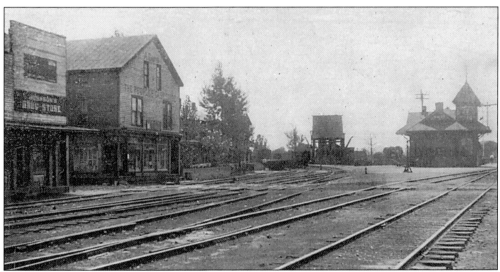

RAILROAD SCENE, LEBANON JUNCTION, KY, c. 1910. Doctor Johnson's Drug Store, on the left, was one of the buildings destroyed by fire in May 1912. The others were A. Davis' three-story Dry Goods, H.H. Hawkins' Clothes Pressing & Cleaning, Ben Jenkins' Pool Room, A. Tatro & Son's Barber Shop, Knights of Pythias Hall, two dwellings, and all out buildings owned by Dr. W.S. Napper. The depot and a water tank are pictured at right. The rails on the left lead to Lebanon, and the ones on the right constitute the main line to Nashville.

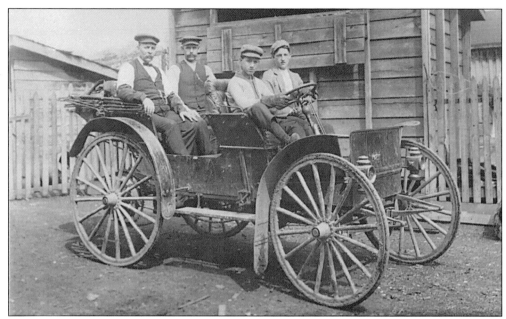

FOUR FELLOWS OUT FOR A SPIN, c. 1910. This two-cylinder chain-driven "Autobuggy" was made by International Harvester Company. The fellows are, from left to right, G.W. Roney, Matt Spinks, Bill Masden, and Tom Collings. The setting is believed to be Pig Tail Alley in Lebanon Junction.

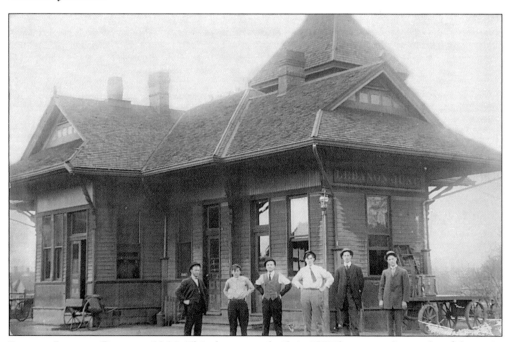

LEBANON JUNCTION DEPOT, c. 1911. This depot was built in 1897 between the tracks of the main line and the Lebanon branch. Passengers could enter the depot from both sides. During the early years, a train passed through every 15 minutes. There have been no passenger trains on these tracks since 1979. Now, only freight trains travel the rails.

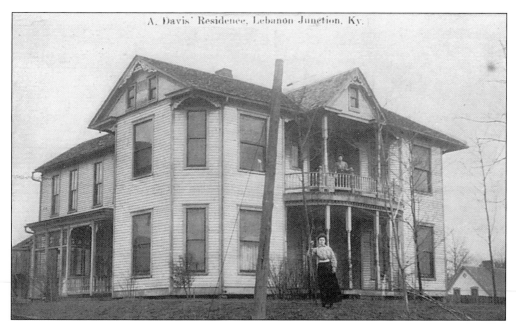

A. Davis Residence, Lebanon Junction, KY, *c.* **1910.** This house on Brook Street sits atop the hill across the street from the Methodist church. Davis operated a three-story dry goods store in Lebanon Junction where it was said, ". . . you could buy any and everything." An elevator made shopping there more convenient. After Davis' death in 1914, the contents of his store were advertised to be sold "at a sacrifice."

Graded School, Lebanon Junction, KY, *c.* **1910.** A graded school was organized in 1880 with 80 pupils. In 1887, land for a school was purchased at the corner of Oak and Brook Streets. In 1903, a new building was built as a school near Rail Road Avenue on Masden Street on land donated by Mack Masden, and his son Dennis. This building was used until 1930.

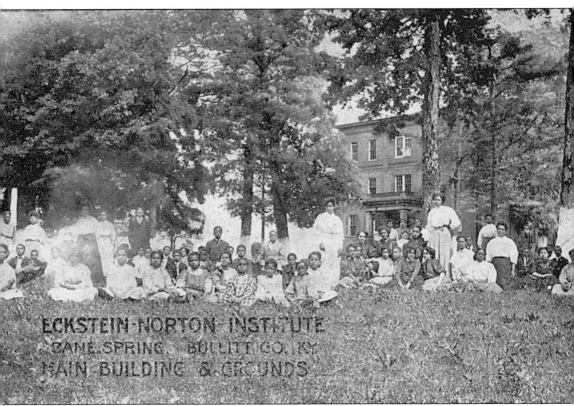

MAIN BUILDING AND GROUNDS, ECKSTEIN NORTON INSTITUTE, CANE SPRING, BULLITT CO., KY, *c.* **1909.** Cane Spring was located about 10 miles south of Shepherdsville on the Bardstown Branch railroad. The Eckstein Norton University of Sciences, Professions, Arts and Trades was incorporated on August 19, 1889. Its purpose was to educate the heart, head, and hands of African Americans. L&N Railroad officials donated more than $3,000 toward the construction of the school on 75 acres of good agricultural land with a large orchard. The main building was a substantial brick structure of 25 rooms with spacious halls and porches. There were six frame buildings with 30 rooms for dormitories, an assembly hall, a printing office, a laundry, and a blacksmith shop. The remains of the buildings can still be seen today near Lotus. The school had several departments: primary, training, normal, prep, college, commercial, dressmaking, and barbering. The enrollment ranged from a low of 52 in the first year to a high of 117 in 1908. The college issued either a BA or a BS degree to 189 graduates from 1892 to 1911. A 1911 school report by Lee L. Brown told of a quartet of students who toured the western and southern states soliciting both funds and students. Several students came from the Pacific Coast after this tour ended. The school was named for Eckstein Norton, president of the L&N Railroad, who was active on the school's behalf. Continued support from Calvary Baptist Church, under the leadership of Dr. C.H. Parrish, raised $400,000 for the establishment of the Lincoln Institute in Shelby County. When Eckstein Norton Institute merged with Lincoln Institute in 1911, its graduates became alumni of Lincoln Institute.

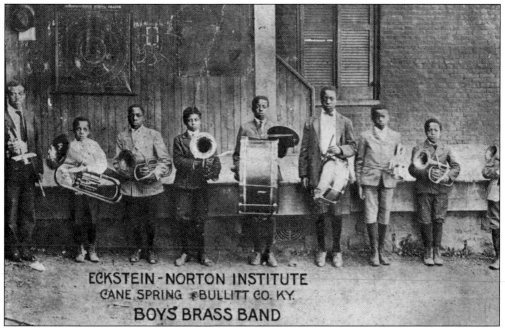

ECKSTEIN-NORTON INSTITUTE
CANE SPRING • BULLITT CO. KY.
BOYS BRASS BAND

BOYS BRASS BAND, ECKSTEIN NORTON INSTITUTE, CANE SPRING, BULLITT CO., KY, *c.* **1909.** The 1911 school report of Lee L. Brown (mentioned at left) reveals that this band, under the direction of Professor R.R. Brown and band leader John White, played before President Theodore Roosevelt at the laying of the cornerstone of the Memorial Building at Abraham Lincoln's birthplace near Hodgenville on February 12, 1909. He added that the band made several trips, both north and west, and played for President Diaz of Mexico and at the cornerstone-laying of Berea Hall at Lincoln Institute.

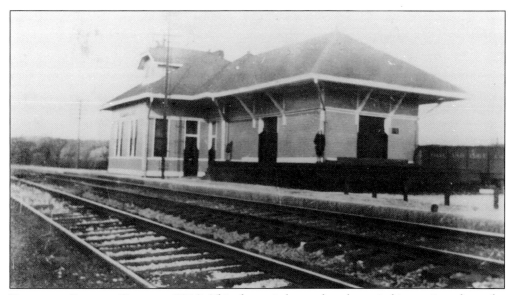

BARDSTOWN JUNCTION DEPOT, *c.* **1910.** This depot is located at the switching point where the Bardstown Branch joins the main L&N line. Known as Bardstown Junction since 1866, it was a small community with a few stores and a church. The post office closed in 1957.

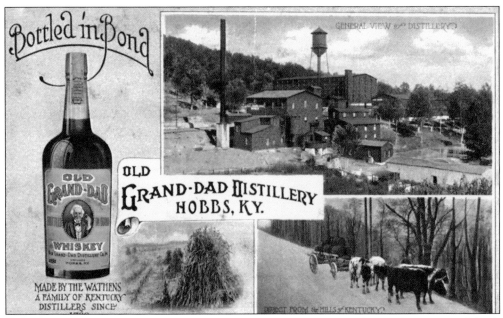

OLD GRAND-DAD DISTILLERY, HOBBS, KY, *c.* 1910. In 1885, R.S. Barber and F.L. Ferriell built a new distillery at Hobbs near the L&N Railroad along the Bardstown Branch Line. They produced the Old Grand-Dad brand of whiskey which R.B. Hayden had established at another site in Nelson County about 1840. In 1899, R.E. Wathen bought the plant and named it Old Grand-Dad. Nace Wathen was the distiller. This plant was destroyed by fire in 1900, but the Wathens rebuilt the distillery and enlarged it to produce four times the product as the old one. Note the reference above to "Made by the Wathens–A Family of Kentucky Distillers since 1788." The note under the often-used ox cart image reads "Direct from the Hills of Kentucky." On the wagon below, a sign also proclaims ". . . Can Be Had at any Good Bar."

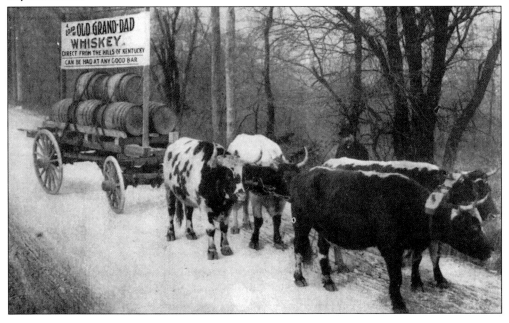

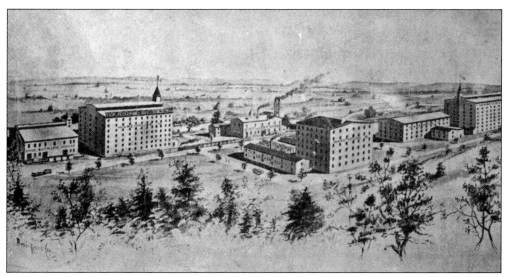

OLD CHARTER DISTILLERY, CHAPEZE, KY, *c.* **1912.** Chapeze is located 2 miles from the branch on the railroad. This distillery was located on the L&N Railroad-Bardstown Branch line prior to 1874. In 1892, the "Old Charter" brand and the A.B. Chapeze Distillery were purchased by Wright & Taylor, a Louisville wholesaler. In 1895, Marion Taylor bought out his partner and continued operation, enlarging the distillery in 1913 to double its output. The distillery continued making whiskey until 1918, and even distributed medicinal whiskey during Prohibition.

BAPTIST CHURCH, MT. WASHINGTON, KY, *c.* **1910.** The Baptist church, on the south side of Main Street, was built in 1874 under the leadership of Rev. James Coleman. It was razed in 1921 when Rev. W.D. Coakley built the new church. The congregation moved the benches, pulpit, and organ to a frame schoolhouse one block away for services during the construction.

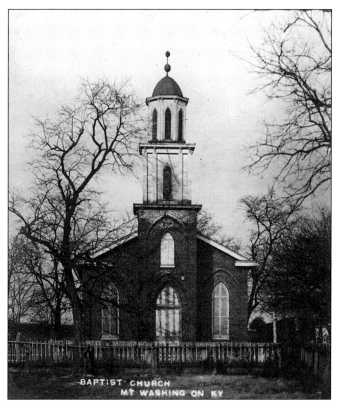

MAIN STREET, MT. WASHINGTON, KY, *c.* **1910.** Mt. Washington, incorporated in 1822, is located 10 miles east of Shepherdsville. For a brief time, the town was known as Mt. Vernon. When notified of another town in Kentucky by that name, however, the townspeople renamed the town in honor of the first President. In 1912, Mt. Washington had a population of 300, with a "good bank, two hotels, four general stores, a millinery store, carriage factory and several other business houses." Settle Hotel was one of two on this street. One block north on the same side was the Kentucky Hotel. The large frame structure on the right was the Methodist parsonage.

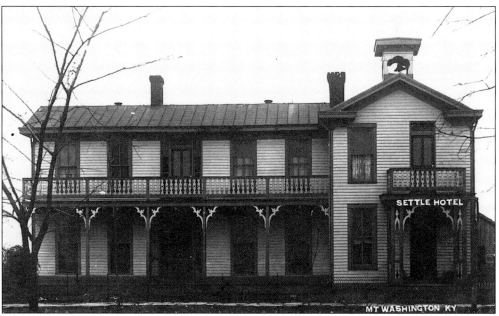

SETTLE HOTEL, MT. WASHINGTON, KY, *c.* **1910.** This building, originally known as Hall House, was first operated as a hotel by Mrs. Mewkirk, mother of Adam H. Settle. He operated it as the Settle Hotel after her death until he moved to Louisville. It was located on the corner of West and Water Streets. M.A. Harris ran it as a hotel in the 1930s. This hotel had indoor bathing facilities but the water had to be hand-pumped to the second floor and heated. Country ham and corn cake meals were enjoyed by the many traveling salesmen who stayed here.

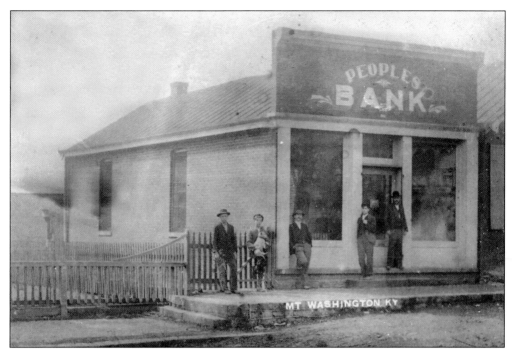

PEOPLES BANK OF MT. WASHINGTON, KY, c. 1910. Prior to 1901, this bank was known as a branch of the Peoples Bank of Shepherdsville and was located in the rear corner of the Cyclone Store. This lot was purchased in 1903 and the building was constructed the next year. The name was changed to The Peoples Bank of Mt. Washington in 1909. It occupied this building on the west side of Main Street from 1909 until 1953.

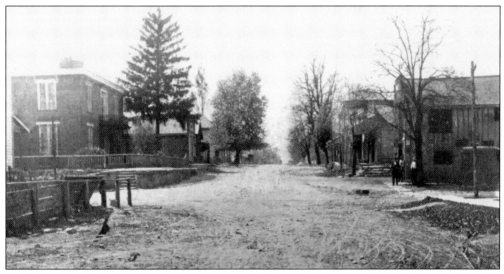

MAIN STREET, MT. WASHINGTON, KY, c. 1910. In the lower left corner of this view are the scales used by the Cyclone Store. The large brick structure to the left is the funeral home built between 1850 and 1865 by Henry Barnes, a noted bridge builder. An outbuilding north of the house was used first as a smokehouse, then later as the location of the Mt. Washington Telephone Exchange.

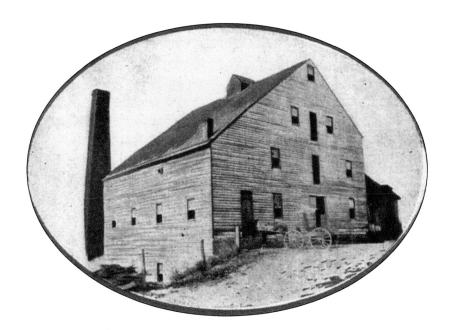

THE SMITHVILLE MILL, c. 1908. This small community at Salt River on the eastern edge of Bullitt County had a grain mill, grocery, and post office until 1917. Today, only part of the mill building remains. Stephen Lloyd operated this four-story grain mill in the 1800s. Later millers were named Stansberry and McKenzie. Clyde Troutman was the owner at the time of this picture, but he did not operate it as a mill.

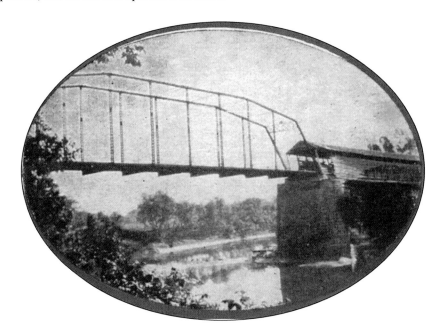

SALT RIVER BRIDGE, SMITHVILLE, KY, c. 1908. Stone abutments support this unusual combination of wooden covered bridge and iron span. This bridge was replaced in the 1920s with an all-iron span and the old iron portion was moved upriver to the Forman Ford.

Two

MARION COUNTY

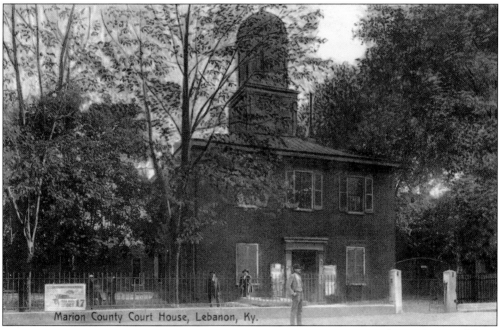

Marion County Court House, Lebanon, Ky.

MARION COUNTY COURTHOUSE, LEBANON, KY, *c.* **1908.** Marion County was formed in 1834 from southern Washington county and named for Revolutionary War general Francis Marion. According to local historian Sam Boldrick, the Marion County Courthouse was erected by Foster Ray for $5,000 shortly after the county was formed. It was located on the site of the present courthouse. A newspaper article dated November 22, 1934, notes that Judge Mayes ordered the courthouse in Lebanon condemned as "unsanitary, inadequate and dangerous." At a fiscal court meeting on January 31, 1935, an appropriation of $65,000 was approved to construct a new one. On November 26, 1935, the $70,000 present courthouse in Lebanon was dedicated.

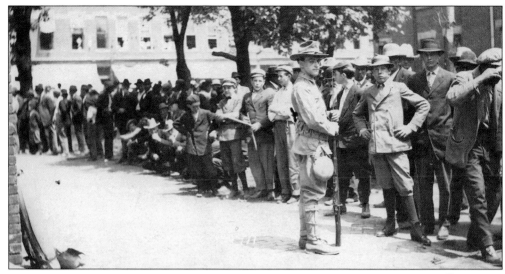

STATE MILITIA GUARDING PRISONER, LEBANON, KY, 1911. On May 7, 1911, police officer John A. Roby became the first Lebanon policeman in 34 years to be killed while on duty. Two men were arrested and taken to the Louisville and Bardstown jails for their own safety. Twenty-five soldiers from Co. E, 1st Regiment of Louisville, accompanied one of the men, John Buckner, to Lebanon for his trial on May 13. As he was brought in chains from the depot, 25 more soldiers from Co. A of Bowling Green helped keep the peace during this emotional time. The one-day trial ended with Buckner being sentenced to the electric chair, then being built at Eddyville. On July 8, 1911, he became the first person in Kentucky to die in this manner. The other man was later tried and given a life sentence.

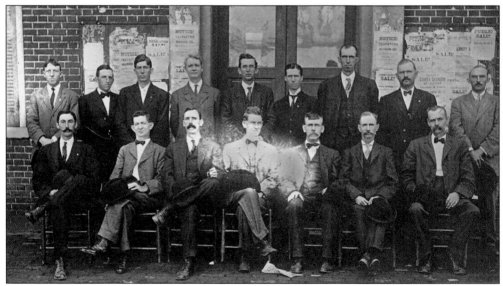

JOHN BOARMAN JURY, LEBANON, KY, 1911. This September 11, 1911 photo of trial officials and jury posed in front of the courthouse relates to the trial of John Boarman, one of two men accused of "outraging" a young Marion County girl. The jury was made up of 11 citizens from Boyle County and one from Marion County. Boarman was found guilty and sentenced to death in the new electric chair at Eddyville.

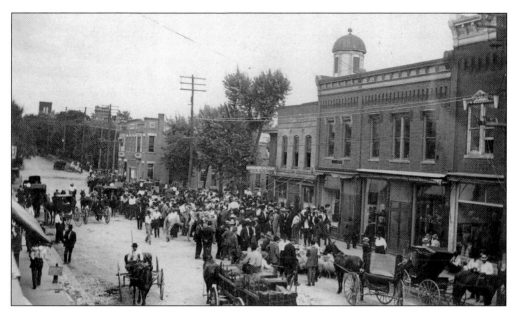

MARION COUNTY COURT DAY, LEBANON, KY, 1907. Kentucky Court Days provided opportunities for shopping, trading, and socializing. In 1911, reports of prices of livestock sales at auction on Court Day showed "two-year-old mules at $138 each, one buck with 19 ewes with lambs $5.90 each, one imported stallion *King of England* $347.50." This was also the day many legal questions were settled. On the right are a general store, Kearns & Smith Furniture and Undertaking, W.C. Carroll Jeweler, and in the last building before the courthouse, a pool room with *The Marion Falcon* newspaper on the second floor.

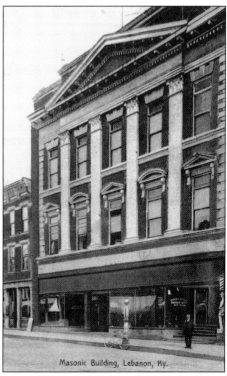

MASONIC BUILDING, LEBANON, KY, *c.* 1910. The Masonic building was erected 1906-1907 at a cost of $40,000. The three-story building had commercial tenants on the first floor, assembly rooms on the second, and the Temple for the Masons on the third. Gov. Procter Knott and his wife, Sarah McElroy, celebrated their 50th wedding anniversary with a party in the second-floor library on June 15, 1908. The building burned in 1962 and a new temple was erected north of town. The Humkey & Purdon Barber Shop is on the right.

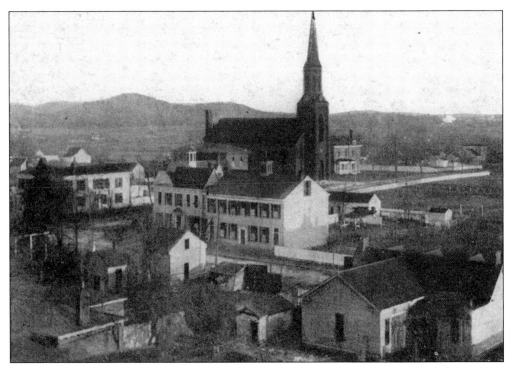

BIRD'S-EYE VIEW FROM MASONIC BUILDING, *c.* **1910.** Looking south from the roof of the Masonic Building on Main Street, the St. Augustine Catholic Church spire soars upward, casting a shadow over St. Augustine Academy and the Sisters of Loretto Convent. Located on the corner of Spalding and Mulberry Streets, these are the two buildings in the center of the view. The Sisters of Loretto erected a girls' school in 1865 with an enrollment of 50 pupils and operated it until 1923 when the public schools expanded.

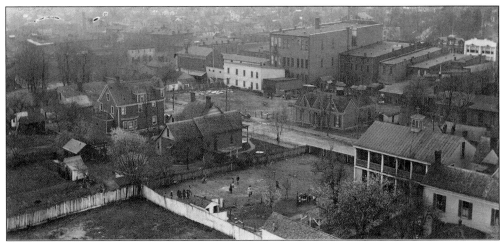

BIRD'S-EYE VIEW FROM ST. AUGUSTINE CHURCH SPIRE, *c.* **1910.** Looking northwest from the top of the church, the St. Augustine Academy and school play yard with a ball game in progress is on the right. In the center is the three-story Masonic Building, with the tower of the First Presbyterian Church on Water Street visible above it. A close look to the left on Proctor Knott Avenue reveals the city hall cupola.

LEBANON CITY HALL, c. 1910. The Lebanon City Hall was erected in 1876. The lower floor was used as a firehouse and the second floor was a meeting room for the town trustees. In 1901, when the population was 3,000 people, the fire-fighting equipment consisted of three independent hose carts and no fire engines. Note the words ENGINE and HOOK & LADDER over the two doors. The cupola and bell have been removed but the building still stands on Proctor Knott Avenue. Lebanon still had horse-drawn fire-fighting equipment in 1911.

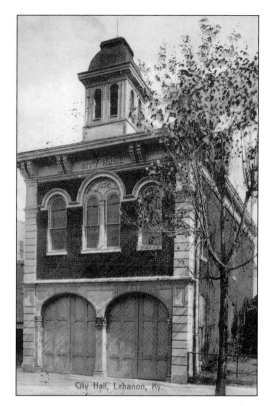

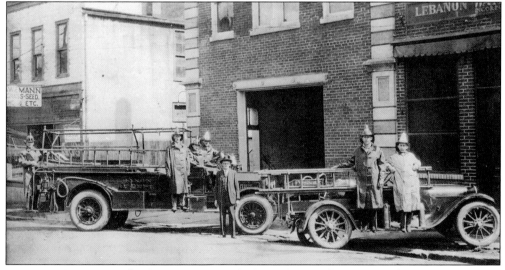

NEW FIRE TRUCKS, 1926. This photo records the delivery of Lebanon's first motorized fire-fighting equipment to the fire station on Proctor Knott Avenue. The Shaw & Mann store, which sold farm machinery, seeds, and grain, is on the left. The Lebanon Water Works building is at right. An insurance map of 1927 notes that Lebanon had a "population of 3,500, and a partly paid Fire Department, One Dodge Chemical Truck, with 40 gallon chemical tank, 125 feet of chemical hose, one Federal hose truck, 1,800 feet of hose, and one Fire Station fully motorized."

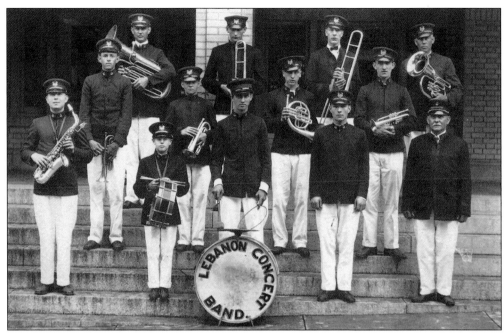

LEBANON CONCERT BAND, *c.* 1925. This talented group of band members was composed of the following: (front row) Charlie Mattingly, Harold Graham, John Violette, Henry Mardis, and Professor Smith; (middle row) Allan Wayne, Babe Carter, Carl Comer, and Joe Williams; (back row) Weard Wayne, Arthur Mattingly, John Lyons, and Jeff Loy.

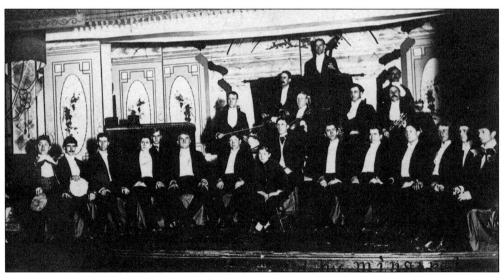

DRESS REHEARSAL OF MINSTRELS (ORCHESTRA) AT LEBANON, KY, MAY 12, 1908. The Old Kentucky Minstrels are pictured on the stage of Lebanon High School. They are, from left to right, as follows: (seated) G. Bruce Edelen, Len A. Carlile, Henry S. McElroy, Walter Rubel, George Lattimer, W.R. Johnston, W.G. Matson, Creel Matson, Will Purdy, Edwin Carlile Litsey, Dr. W.S. Hodgen, Dave Hayes, Richard Spalding, Arthur Smith, and Foster Ray; (standing) C.J. Edmonds, Dr. Charles Kobert, Will Timmons, Lewis Edmonds, Clarence Litsey, Hogue Edelen (lower), and Wallace Litsey (behind Hogue Edelen).

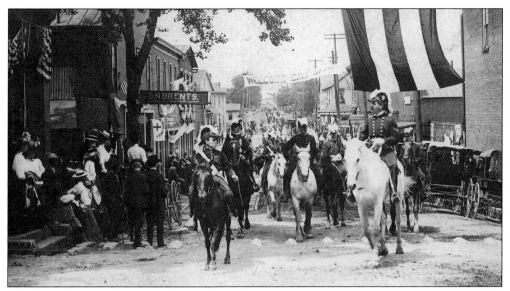

THE KNIGHTS TEMPLAR OF KENTUCKY 61ST CONCLAVE, LEBANON, MAY 20, 1908. Businesses were decorated with bunting, music filled the air, and homes were opened for southern hospitality. On Wednesday morning, after a 9:30 a.m. religious service in the Baptist church, the grand parade formed and marched through the streets. Anticipating the need, local tailor Bowman advertised "I am making Black Doeskin Full Dress Trousers to measure for $7.50. Be ready for the Conclave in May." This view is on Depot Street. All Knights in uniform were led by Chief Marshall Lee A. Scearce, on the white horse at right. On horseback at front left is Grand Captain General Pete Browning of Lexington. The parade proceeded on horseback, in carriages, and on foot meandering along the streets of Mulberry, Main, Market, Chandler, Harrison, Spalding, Walnut, Depot, and Water before passing in review in front of the Masonic Building on Main Street. Roads were lined with spectators as drill teams performed and bands played.

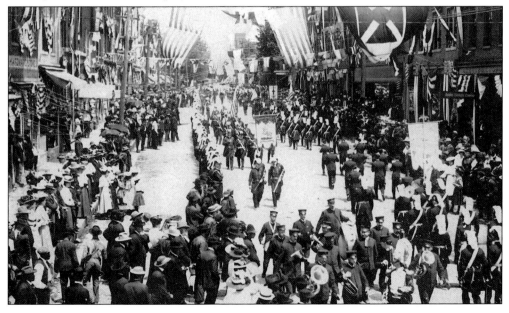

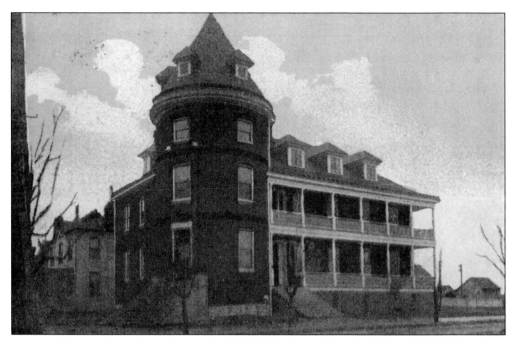

ELIZABETH HOSPITAL, LEBANON, KY, c. 1910. The Elizabeth Hospital on the corner of Main and Harrison Streets was built by Dr. R.C. McChord in 1898 at a cost of $12,000 and opened to the public the next year. Named in honor of his wife, it was a private hospital utilized solely for his patients. In 1908, it had hot water heat and electric lights. Offices were in the tower and the operating room was in the front wing. The kitchen was on the first floor and the patients' rooms opened off the porches.

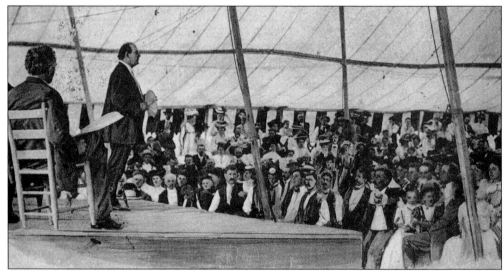

BRYAN DAY AT CHAUTAUQUA, LEBANON, KY, c. 1908. The Chautauqua was an entertaining and educational event, with visiting political and literary speakers. Famous attorneys, politicians and crusaders such as William Jennings Bryan often enthralled local audiences for hours at a time. Band concerts, famous musical performers, and local baseball teams entertained the community during a week-long affair.

34

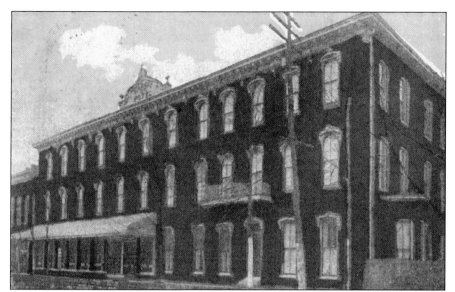

HARDESTY HOTEL, *c.* **1910.** A card advertised: "The new Hardesty Hotel, long known as the Norris House, is a commodious and handsome structure, erected in 1879. The house has modern equipments throughout and every arrangement for the comfort and convenience of the guests has been provided. There are 65 rooms in the building with a large and handsome addition being erected to greatly increase the accommodations. The sleeping accommodations are all outside rooms, giving every advantage of light and air."

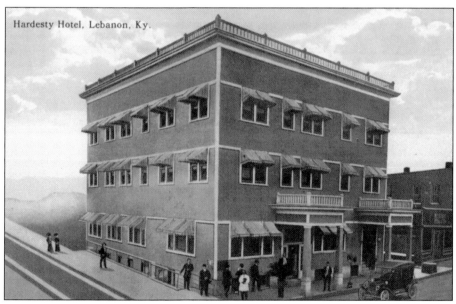

NEW HARDESTY HOTEL, *c.* **1920.** The new Hardesty Hotel was erected by J.B. Hardesty one block west of the old Norris House/Hardesty Hotel/Vaughn Hotel on Main Street. A 1911 visitor to the old hotel called it "The Seelbach of Lebanon" in a postcard message. Hardesty sold the older hotel to J.T. Vaughn of Campbellsville in 1911 and went into retail business. He built a new hotel (above) to rival the old one in convenience and furnishings. It was on the corner and faced Depot Street.

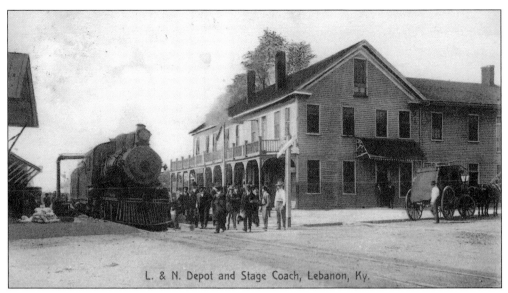

L&N Depot and Stage Coach, Lebanon, Ky.

L&N DEPOT AND STAGE COACH, LEBANON, KY, *c.* **1910.** This scene of depot, train engine, hotel, and stagecoach was typical of many Kentucky towns in the early 20th century. On the right is the Guthrie House, the passenger depot and hotel. Commercial and private travelers were important contributors to the economy. The railroad arrived in Lebanon on November 10, 1857, and trains were operating on it by March 1858. By 1866, the tracks were extended to Stanford, 37 miles away; then to Richmond by 1868. By 1883, the track had been extended to the Tennessee line.

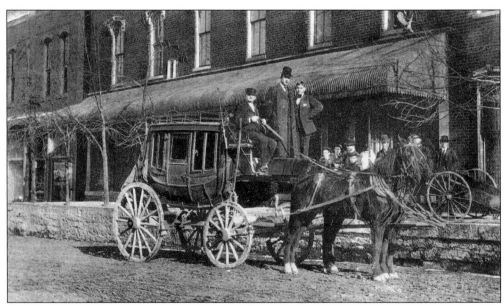

LEBANON & SPRINGFIELD STAGE LINE *c.* 1909. Charles Moore operated a stagecoach between Springfield and Lebanon. It advertised "Leaving Springfield 8 am—arrive Lebanon 10 am. The returning stage leaves Lebanon upon the arrival of the down train at 8 pm." Pictured on the stage in front of the Norris House Hotel are Charlie Moore, Walt Hardesty, and Pete McKenna. Jim Bunnell is the man in the derby beyond the horse's neck.

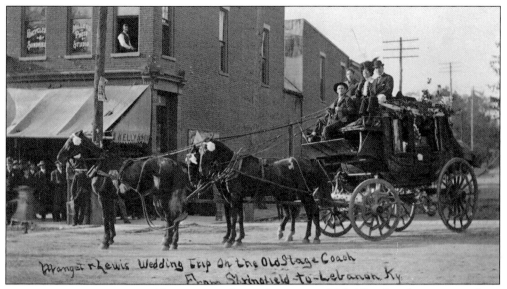

MANGEL AND LEWIS WEDDING TRIP ON OLD STAGE COACH, *c.* **1906.** The four-horse stage from Springfield to Lebanon was used by the Mangel and Lewis wedding party for their wedding trip. It is pictured at the intersection of Main and Spalding, coming from Springfield. Photographer J.W. Miller is seen seated in his studio window.

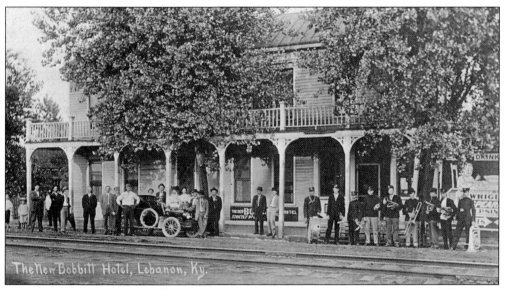

NEW BOBBITT HOTEL *c.* **1904.** This hotel was located on Water Street across from the depot. In 1901, this hotel was called the Bricken Hotel and, by 1904, it was operated by J.D. Bobbitt & Son. In front of this building, during the summer of 1908, a confrontation occurred. Two noted hotel competitors, Virgil Bobbitt and John Hardesty Jr., met passengers at the railway station to solicit their patronage. They were to stay behind an agreed line until the passengers unloaded. But in the crowd, Bobbitt was shoved and knocked to the ground. He quickly went to his hotel a few feet away and returned with a revolver. In the fray, Ham Hardesty was shot once in his shoulder and Bobbitt was struck a blow to the head.

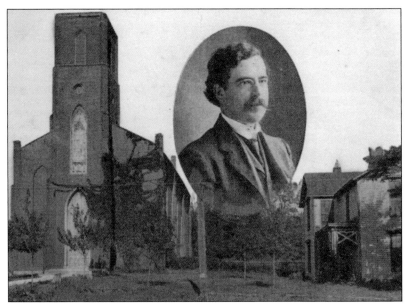

FIRST PRESBYTERIAN CHURCH, LEBANON, KY, *c.* **1908.** This church, located on Water Street, was dedicated in June 1857. The parsonage on the right was built in 1876. The church building was damaged by cannon fire during the Civil War and the church petitioned the federal government for payment of damages. It is reported that the church did not receive payment and was unable to reconstruct the building in as elegant and stately a condition as before the war. The church was dismantled in 1930-1933. Rev. William Mahon is pictured.

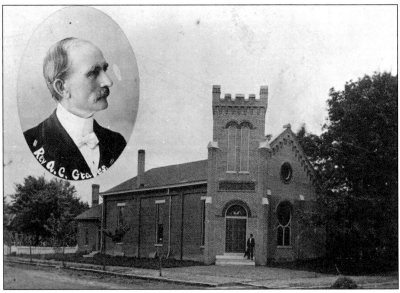

BAPTIST CHURCH, LEBANON, KY, *c.* **1906.** This church, located on the corner of Mulberry and Harrison Streets, was dedicated on October 30, 1860. During the 1908 Knights Templar Conclave, a morning service was held here with Rev. Charles H. Prather of the Methodist Church South delivering the sermon. Rev. A.C. Graves was the minister from March 13, 1892, until his death in 1912. The building was replaced with a new structure in 1924.

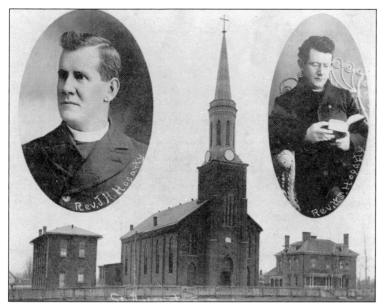

St. Augustine Catholic Church, Lebanon, KY, *c.* **1908.** Father Ivo Schact began construction of this church in 1867 and completed it in 1869 at a cost of $25,000, excluding altars, bells, and furnishings. This church had the largest congregation in Lebanon at this time. On June 19, 1908, Fr. James A. Hogarty (left) celebrated his Silver Jubilee. He had served as pastor of "St. A" since 1894 and continued to serve until his death in 1937. His brother, Fr. William P. Hogarty (right), served as deacon at the Mass. The rectory at right was built in 1905 and remodeled in 1913. At left is the boys' school, built in 1883 and operated by the parish.

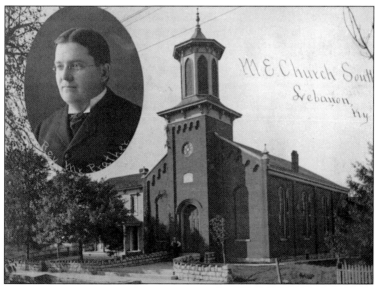

M.E. Church South, Lebanon, KY, *c.* **1908.** In 1908, this building, situated on College Street, was known as the Lindsay Chapel Methodist Church. Located across from the Lebanon High School, its brick tower was 45 feet in height. Rev. Charles H. Prather was the minister.

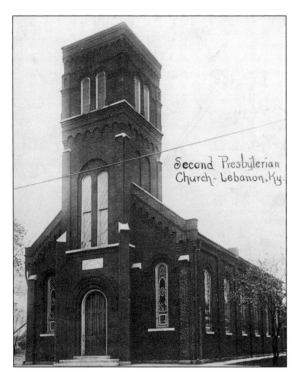

Second Presbyterian Church - Lebanon, Ky.

SECOND PRESBYTERIAN CHURCH, LEBANON, KY, c. 1910. The Second Presbyterian Church on East Main Street was dedicated in January 1871. The early Presbyterian congregation at Lebanon split over political and theological differences. The members of the Second Presbyterian Church belonged to the Southern Assembly. Both congregations used the old Presbyterian building for services until an uproar in 1867 caused this group to build their own church. The brethren of the Baptist church invited them to worship in their church until a new building was completed two years later.

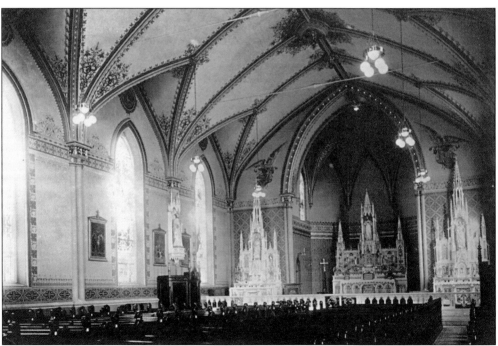

ST. AUGUSTINE CHURCH, LEBANON, KY, REMODELED 1911. When Fr. James Hogarty desired to make improvements at the church in 1907, Bishop William George McCloskey denied him permission. Confident that he had good reasons for doing so, Fr. Hogarty appealed to Archbishop Henry Moeller of Cincinnati, who overturned McCloskey's prohibition.

PROCTOR KNOTT CHAUTAUQUA GROUNDS, *c.* **1908.** The Proctor Knott Chautauqua was first held in 1905. Three years later announcements of the summer event listed speakers, music, and a series of six ball games. The ten-day tickets sold for $2 for adults and $1.25 for children. A new auditorium was constructed to seat 1,500 people with portable benches. This new facility had a building with a clear space of 60-by-100 feet. Gravel walks improved the grounds. The leased lots for cottages or tents were auctioned off to the highest bidders earlier in the year. The tents are visible on each side of the walk.

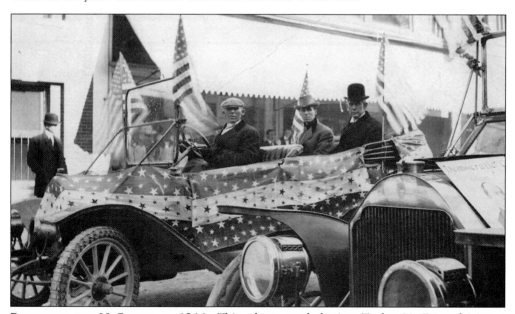

POLITICIANS FOR MCCREARY, *c.* **1911.** This photo card depicts Taylor M. Estes driving a bunting-wrapped car with Henry McElroy and Hon. Ben Johnson, congressman from Bardstown. They were attending the McCreary Rally in Lebanon. Congressman Johnson was a supporter of former governor James B. McCreary in his second successful race for governor in 1911.

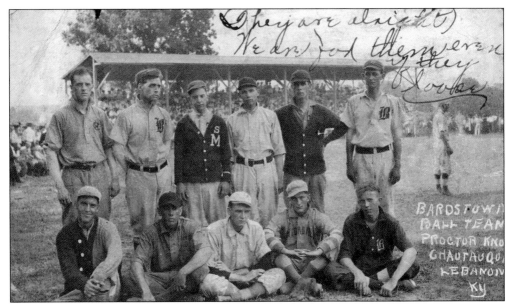

BARDSTOWN BASEBALL TEAM, 1911. Playing at the Proctor Knott Park in Lebanon, KY, during the Chautauqua of 1911, these Bardstown players were cheered on by the unknown sender of this post card. "(They are alright) We are for them even if they loose."(sic) The players are, from left to right, as follows: (front row) Victor Kelly, Clyde Brown, Edwin Wilkerson (Taylorsville), ? Pike (Taylorsville), and Clifton M. Atherton; (back row) Will H. Fulton, Steve G. Fulton, John S. Kelly Jr., A. Cambron Wilson Sr., Ernest N. Fulton, and Ballard B. Jewell.

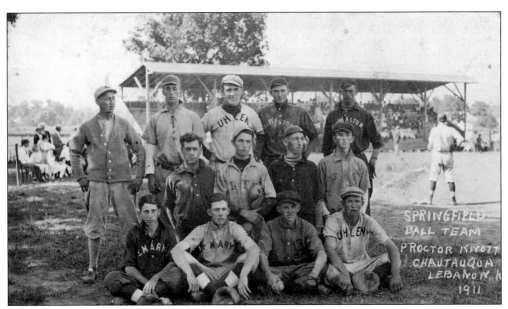

SPRINGFIELD BALL TEAM, 1911. The 1911 Lebanon Chautauqua Baseball Series included teams from Lebanon, Campbellsville, Greensburg, Columbia, Springfield, and Bardstown. The winner was the Springfield team, which shared a $35 gold prize. The runnerup, Lebanon, was awarded $15.

42

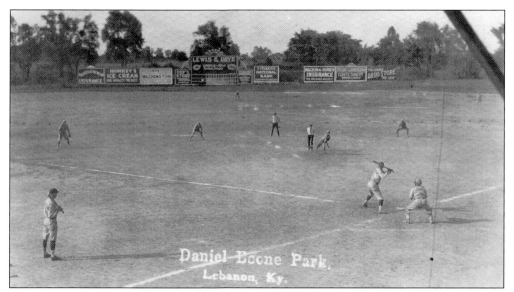

DANIEL BOONE PARK, LEBANON, KY, *c.* **1923.** The Lewis & Drye scoreboard in the center field fence reflects the visitors leading the home team 6-0 after four innings. The short-lived ballpark was located on North Spalding Avenue between Harrison and Hood Streets. The umpire calling balls and strikes is standing behind the pitcher, and the base umpire is positioned near second base.

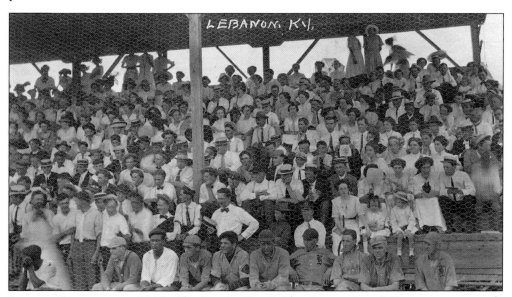

BASEBALL GRANDSTAND *c.* **1911.** The Proctor Knott Chautauqua Association was a nonprofit organization, ". . . run but for the betterment and upbuilding of our own and surrounding communities." Former governor Proctor Knott donated the grounds on the southern outskirts of Lebanon. In 1911, a grandstand was built behind home plate. It seated 1,000 spectators and had baseball netting between the playing field and grandstand. The 1911 Chautauqua schedule listed band concerts at 9:30 a.m. and 1:00 p.m., followed by lectures and a baseball game every afternoon at 4:00. In the evening, another band concert was followed by local talent performances and ended with a lecture at 8:30 p.m.

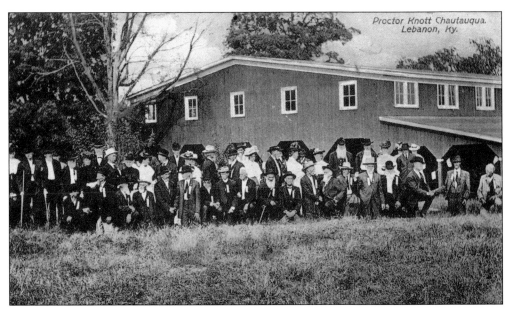

BLUE & GRAY REUNION, 1908. This reunion scene at the Chautauqua grounds, on September 9, 1908, depicts veterans from both the North and South, musing upon and telling tales—often of loyalties, devotion, and sacrifices. About 300 people attended the first day, one-half being former soldiers. The second day, an estimated 1,000 people listened to various speakers. Though a bountiful lunch was provided, the veterans preferred to broil their meat on sticks, eat hard tack, and drink black coffee while sitting on the ground as they did during wartime.

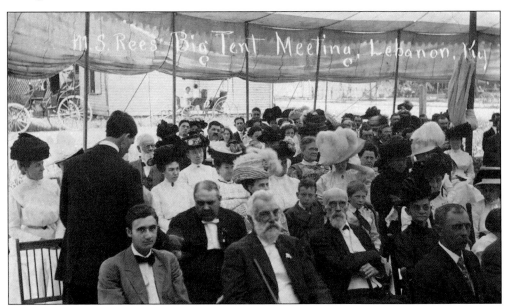

M.C. REES' TENT SHOW, c. 1910. Lectures, political speeches, temperance meetings, and religious revivals were frequently held in outdoor settings under large tents. This real photo image reveals formally dressed Marion Countians of all ages. Tent meetings provided opportunities for ladies to display their fashionable hats and new attire.

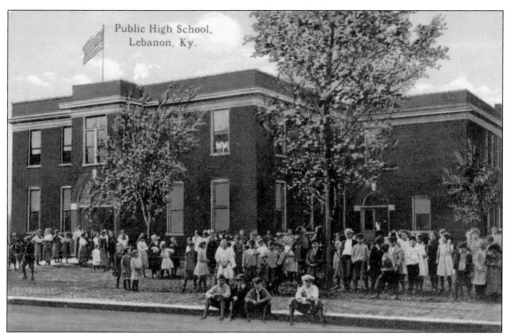

PUBLIC HIGH SCHOOL, LEBANON, KY, *c.* **1915.** This school building was constructed in 1883 on College Street. It was first a graded and high school; after the new high school was built in 1919, it was used only as a graded school.

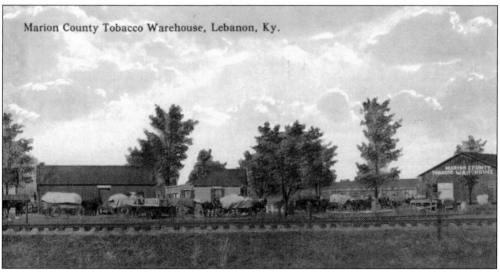

MARION COUNTY TOBACCO WAREHOUSE, LEBANON, KY, *c.* **1920.** This warehouse was the expected site for action by Night Riders in 1908. According to the newspaper, "Six or so, well-mounted men rode down Main Street toward the Warehouse. The night policemen rushed toward the warehouse expecting trouble, but the riders turned off to the Bosley-Barr furniture store to shop after hours, explaining that they had been too busy to come during regular store hours." A news article of September 1908 noted that R.E. Young and J.M. Rains had leased their warehouse near the depot to the American Tobacco Co. as a leaf tobacco warehouse.

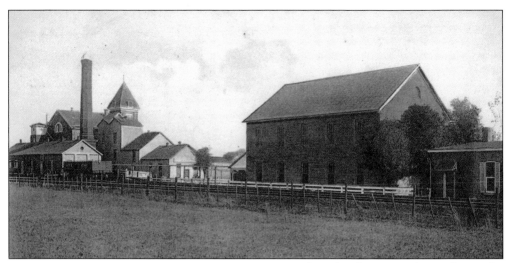

MUELLER, WATHEN & KOBERT DISTILLERY, *C.* **1910.** This distillery was located on the Campbellsville road. In 1908, Charles Kobert & Co. made "Cumberland" bourbon as RD #299 in the frame portion of the building on the left and (R.N.) Wathen, (Hans) Mueller & Co. RD #270 distilled "Rolling Fork" whiskey in the brick portion. During Prohibition, a coal and feed company run by Wathen used this site. In 1931, the brick still house burned and the plant was sold to John A. Wathen. He sold it to Schenley Distillers, which made the last whiskey here in 1949.

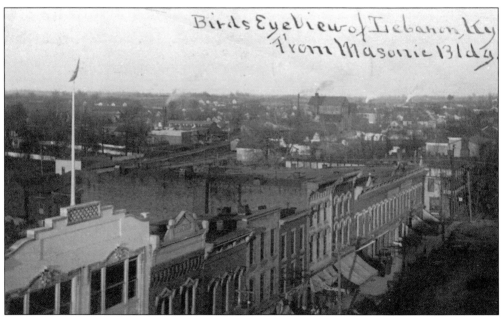

BIRD'S-EYE VIEW FROM MAIN STREET, *C.* **1910.** This view looks east across Lebanon rooftops. At left is the flagpole atop "The Drugstore Building," occupied in 1908 by Gilkerson & Beeler Drugstore, which advertised a "circulating library." Farther down the block, the corner building was owned by Photographer J.W. Miller, who had his studio on the second floor. Directly across Spalding Avenue and on the corner, is the Veranda Hotel. This is a rare photo of this hotel, which was demolished to build the post office in 1911.

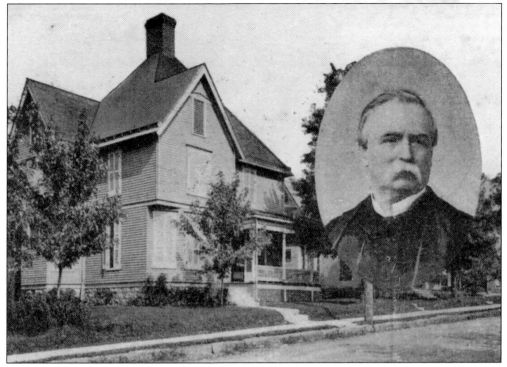

RESIDENCE OF EX-GOVERNOR KNOTT, LEBANON, KY, *c.* **1910.** James Proctor Knott was born at Raywick in 1830 (see image below). He moved to Memphis, MO, in 1850 and was admitted to the bar. He began his practice of law a year later. Knott served as a member of the House of Representatives in 1857 and, after resigning, filled the office of attorney general of Missouri in 1859-1860. He returned to Lebanon and began a law practice in 1863. He served in the Congress from Kentucky in 1867-1871 and 1875-1883. Knott declined to be a candidate for Congress, but served as governor of Kentucky from 1883-1887. He taught at Centre College and was the dean of the law school. He died at Lebanon in 1911. Market Street was renamed Proctor Knott Avenue in his honor.

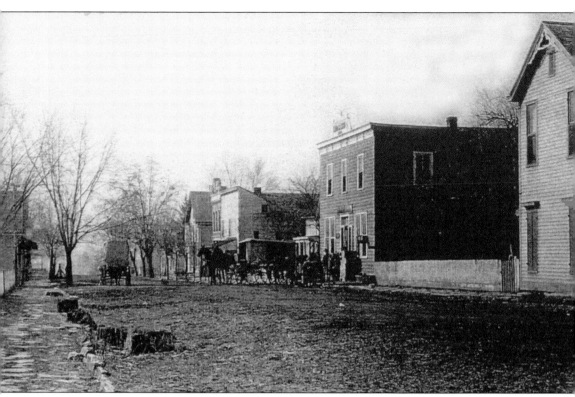

MAIN STREET IN RAYWICK, *c.* **1914.** John G. Cecil and Sarah Hogsdon Cecil, his wife, resided in the frame residence at right. Sarah had a millinery shop in the front portion of the house. Beyond the fence is John Cecil's general store, which he constructed in 1903. Continuing down Main Street are the Edelen residence, the Hubert Edelen grocery store, and a building that housed The Bank of Raywick throughout its brief existence in the 1920s. Owned by Will Webster, this state-chartered bank had only one employee. Next is J.W. "Will" Bowman's large store, the upstairs portion of which was used for dances, plays, and roller-skating. Next is the Hughes residence in which the telephone exchange, operated by Mr. and Mrs. Jesse Raley in the early 1900s, was located. At left, on the corner of Cross and Main Streets, is Will Bickett's general store, which later became Bickett's Poolroom. An apartment house known as "The Ark," owned by J.I. Byrne, was later constructed down the street on the left across from the bank building. Other noted enterprises during the early years include Head Distillery, a tanning yard, two blacksmith shops, a drugstore, and three mills, one of which became the site of a broom factory in the 1950s. There were both a Catholic church and a Methodist church in Raywick until the late 1930s, when the Methodist church was moved to the High View area.

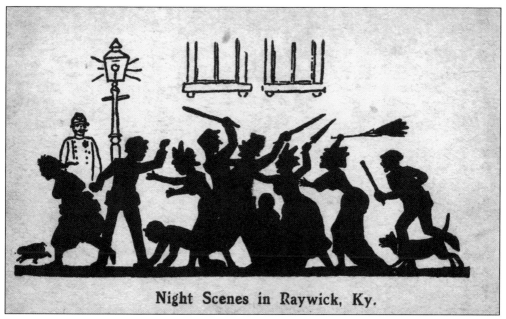

NIGHT SCENES IN RAYWICK, *c.* **1911.** This silhouette postcard, mailed from Raywick to Gleanings, KY, in January 1911, characterizes an image of violence and lawlessness many Kentuckians had of this small town. Although it certainly had its share of moonshiners, most of the crimes that occurred in Raywick, especially at local places of entertainment, were committed by outsiders.

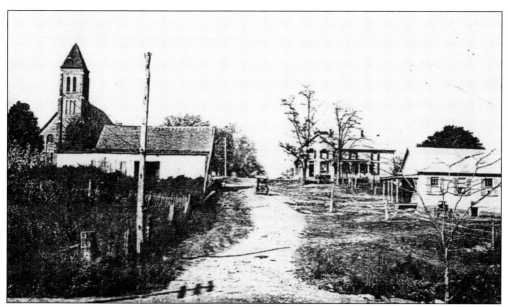

STREET SCENE IN RAYWICK, *c.* **1918.** St. Martha's one-room school for black children is at far right. At center right is the old Raywick School, which also housed the Ursuline Sisters, who served as teachers. The barn at left was at one time a hotel and later the residence of Will and Effie Bickett. The imposing St. Francis Xavier Catholic Church at far left was built in 1887 and was the second church built by the parish.

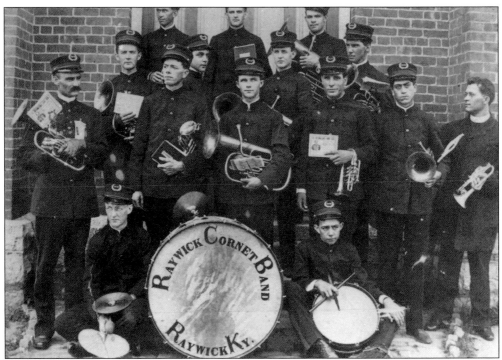

RAYWICK CORNET BAND, *c.* **1905.** This talented group of young men was composed of the following, from left to right: (front row) P.E. Hughes and Wallace Mitchell; (second row) C.D. "Pete" Russell, Clarence Kelly, Albert Cecil, Johnny Thompson, Lawrence Thompson, and Father Andrew C. Zoeller; (third row) John Cecil, Lee Bowman, Bernard Hughes, and Lynn Blair; (back row) William Bickett, unknown, and George Clark.

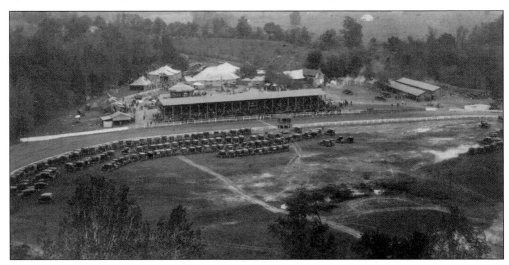

MARION COUNTY FAIRGROUNDS, *c.* **1910.** This aerial view of the Marion County Fairgrounds reveals the large grandstand, horse track, and parked vehicles during its heyday. The September 2, 1911 *Lebanon Enterprise* listed the sale of the Marion County Fairgrounds property: 40 acres of land, 1/2 mile of track, two large stock barns, forty-one box stalls, and a cottage on Jackson's Lane about one-half mile from town. The property brought $4,600.

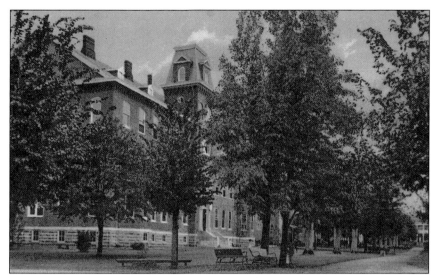

LORETTO ACADEMY, LORETTO, KY, *c.* **1910.** A 1907 advertisement promotes the advantages of "Loretto Academy, Boarding School for Young Ladies. Founded in 1812, Chartered 1829, Oldest Educational Institute in Kentucky, yet thoroughly progressive and up-to-date. Location healthful, grounds extensive and beautiful. School building new and commodious, equipped with all modern improvements. Cuisine is excellent. Well-filled library, including all Standard Works and leading periodicals. Course of study thorough and comprehensive: monthly reports sent to parents or guardians. Vocal department in charge of a graduate from the Conservatoire de Paris. Conveyance from the Academy meets morning and evening trains. Phone connects Academy with station, whence telegrams may be sent to all points."

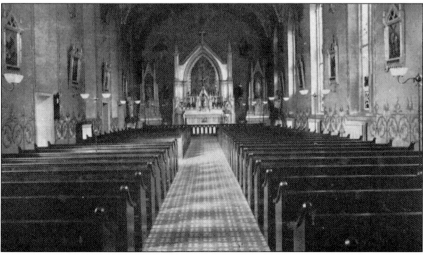

INTERIOR OF LORETTO CHURCH, NERINX, KY, *c.* **1910.** This is the church of the Sisters of Loretto at the Foot of the Cross. It had modern gas lights and steam heat. Remodeling in the 1980s removed the Victorian details and placed the altar in the center of the church. One year after the 19th Amendment was ratified in 1920 giving women the vote, the Sisters of Loretto petitioned the Marion County Court for a place to vote. A new precinct needed 350 voters, and the Sisters noted that there were enough votes in residence at the academy to justify the new poll. The new precinct was bounded by academy property.

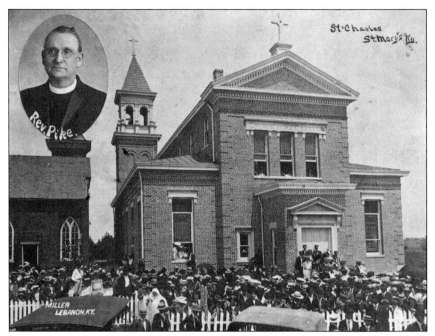

ST. CHARLES CHURCH, ST. MARY'S, KY, *c.* **1907.** At left is the old church built in 1832. The congregation did not want the old church to be demolished when plans were made for a larger one, so it was built alongside it. The cornerstone was laid for the new church in 1903 and dedicated in 1907 by Fr. James J. Pike. In May 1907, a bell brought from Europe by Father Nerinckx was removed from the old church and presented to Loretto Academy by Fr. Pike. Inside the church, the life-sized crucifix brought from France by the Jesuit Fathers about 1833 forms the centerpiece over the altar.

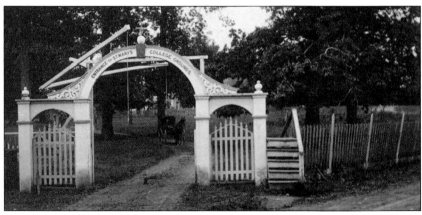

ST. MARY'S COLLEGE ENTRANCE, ST. MARY'S KY, *c.* **1906.** St. Mary's College grounds extend to the St. Mary's station 3/4 of a mile from the college. Three trains from Louisville arrived daily in 1915. The Fathers of the Congregation of the Resurrection, a teaching order, operated the school. The 1915 prospectus notes, ". . . college furnishes a good table, common to the faculty and students. A large dairy, extensive vegetable garden, farm, bakery and abattoir, supply the table with the best and freshest." In October 1897, all the students waited at the depot to see the "Great Silver Orator," William Jennings Bryan. His train stopped for him to address the boys.

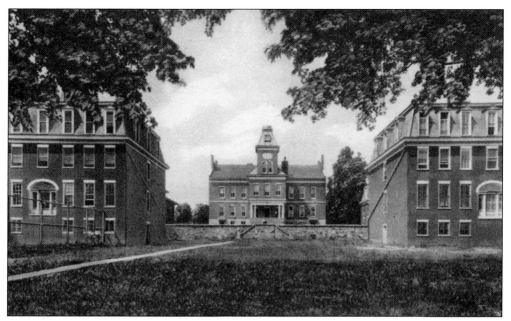

ST. MARY'S COLLEGE, *c.* **1910.** The center building is Byrne Hall, named in honor of Rev. Robert Byrne, founder of the college. It was erected in 1884 at a cost of $20,000 by Fr. V.T. Lanciotti, C.R. A 6-foot statue of Lourdes was placed above the front entrance of Byrne Hall in 1896. A few years after the college was founded in 1821, the Columbia building on the left and the Refectory building on the right, were erected. Byrne Hall was destroyed by fire in March 1973.

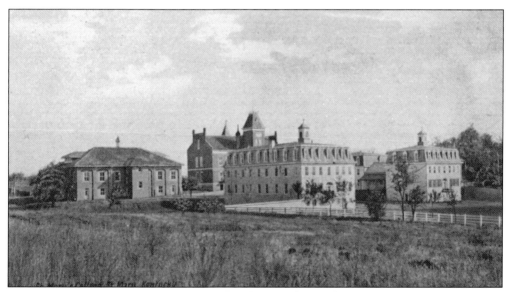

ST. MARY'S COLLEGE, *c.* **1910.** The three buildings in front of the main building were raised one story in 1894. At that time, water and a steam heating system were installed. These buildings were reserved for dormitories. In 1901, Fr. John Fehrenbach erected a gym and installed a laundry. By 1914, a new electric system had been installed in the chapel, gym, and other buildings.

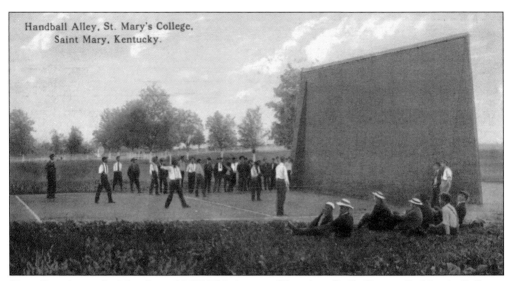

Handball Alley, St. Mary's College, Saint Mary, Kentucky.

HAND BALL ALLEY, ST. MARY'S, *c.* **1917.** This is one of four handball alleys at St. Mary's College. A spacious athletic field, three baseball diamonds, gridirons, tennis court, croquet lawns, and a swimming pool are listed in the 1915 college yearbook. The college program offered several sports and had many newsworthy teams. Baseball and basketball teams from Notre Dame University in South Bend, IN, played for the first time in Kentucky at St. Mary's. The 1908 St. Mary's football team was the state champion. In 1915 and 1920, St. Mary's had the best basketball teams in Kentucky.

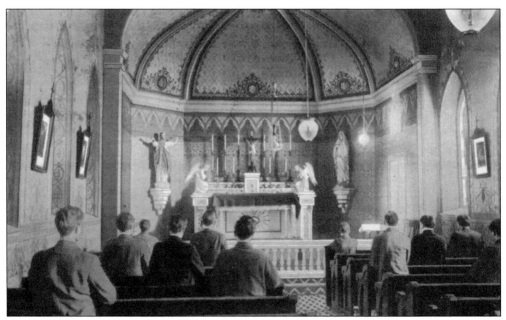

ST. MARY'S CHAPEL, *c.* **1910.** This view shows the college chapel after remodeling in 1893. It was attached to the Refectory building. The installation of new stained-glass windows and an ornately painted sanctuary provided decorative details to the old chapel. In 1912, three more windows, at a cost of $75 each, were donated by James M. Collins of Maysville, R.N. Wathen of Lebanon, and J.B. Alberts, a Louisville artist.

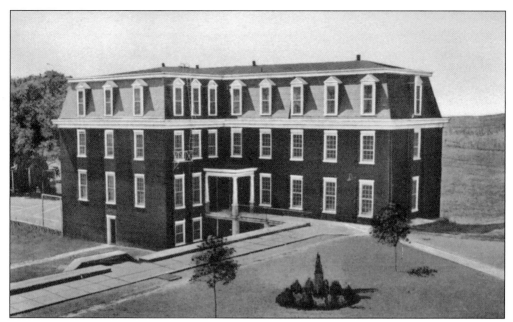

COLUMBIA BUILDING, ST. MARY'S COLLEGE, *c.* 1910. Fr. Robert Byrne founded St. Mary's College in 1821 near St. Charles Church. It was the oldest Catholic college for men west of the Alleghenies, and the third oldest in the nation when it closed in 1976. In its first 12 years, the school had educated about 1,000 young men. This building was erected shortly after the college was founded.

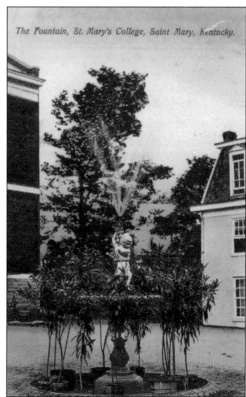

THE FOUNTAIN, ST. MARY'S COLLEGE, *c.* 1915. This picture was taken by J.W. Miller of Lebanon in 1915-1916. The college was turned over to the French Jesuits in 1831, who remained until 1846. The diocesan priests administered it until the Resurrectionist Fathers arrived to operate it as a seminary in 1871. They continued the seminary until 1976.

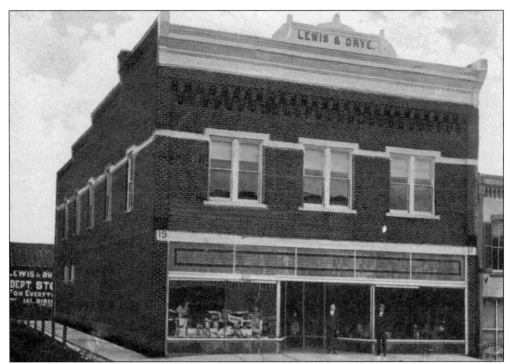

LEWIS & DRYE DEPARTMENT STORE, BRADFORDSVILLE, KY, c. 1915. Edgar Lewis and Don V. Drye organized their department store business in September 1905. Lewis was a traveling salesman who contributed financially to the business while Drye was in charge of its day-to-day operations. This image shows the two-story brick building, constructed in 1911, and a storage building at left in the rear.

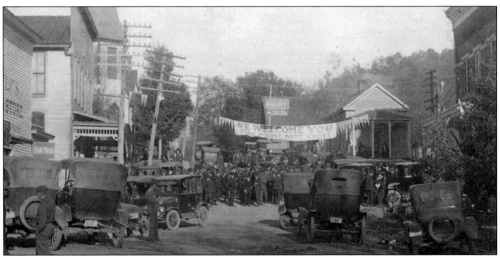

CELEBRATION IN BRADFORDSVILLE, KY, c. 1915. A "We Welcome You" banner extends across Main Street beyond Richard Chelf's store at left and the Lewis & Drye Dept. Store at right. A sign above the banner advertises the Kuloff, a popular business located in the basement of the department store. It contained a soda fountain and dining area in which meals and ice cream were served and was advertised as, ". . . kull in the summer–cozy in the winter."

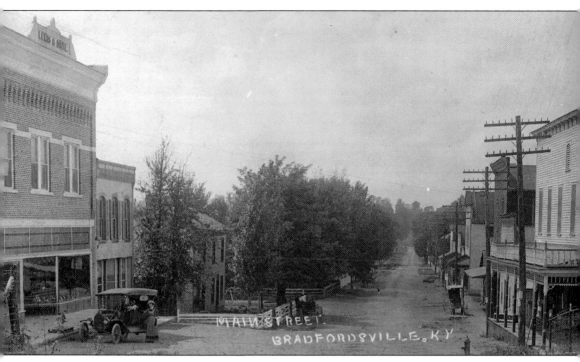

Main Street in Bradfordsville, KY, *c.* **1918.** The Lewis & Drye Department Store building is at left. Groceries were sold on the right side of the main floor and fabrics, clothes, and shoes were sold on the left. A millinery was located on the second floor. The next structure was the Rolling Fork Bank. Next to it was Dr. J.W. Purdy's two-room dental office, which is obscured by trees in the photo. He and his wife, Margaret, and their two young sons, Edgar and George, occupied the two-story residence with the white fence in front. These boys had a small white poodle named Teddy who insisted on having a bowl of coffee with the family each day before he would eat his breakfast. At right is the Powell building that was bought by Don V. Drye, who established a movie theater in the upstairs portion and a post office downstairs. A poolroom managed by Richard Chelf occupied the next structure. Paul Hunter operated a garage on the main level of the third building and maintained his living quarters on the second floor. School plays and operas were performed on the third floor of this frame building. A two-story frame Masonic building appears next and is followed by a one-room barbershop building, owned and operated by Henry Veatch. Next to this structure was the D.O. Burke & Bro. Square Deal building. A fire later destroyed all of the buildings on the right side of Main Street. During the period from 1910 to 1930, Bradfordsville had three churches, a bank, an overall factory, three medical doctors, and a dentist.

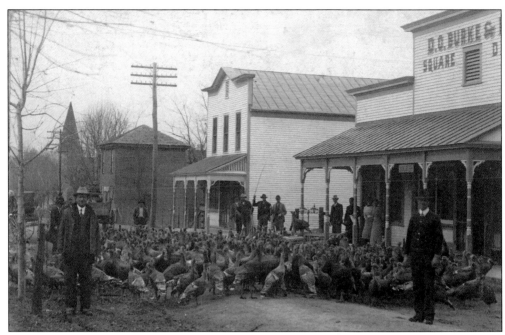

A DROVE OF TURKEYS IN BRADFORDSVILLE, KY, *c.* **1915.** The man with the drover's whip is herding turkeys to the D.O. Burke & Bro. Square Deal store. Burke shipped turkeys to both Louisville and Lebanon. He often bought farm products from area residents. D.O. Burke also owned a millinery and dry goods store next door. Women working with the Red Cross made bandages for soldiers during World War I on the second floor of this building. Beyond the two-story frame residence is a Baptist church. For a few years, both Baptist and Presbyterian congregations held their services there on alternating Sundays.

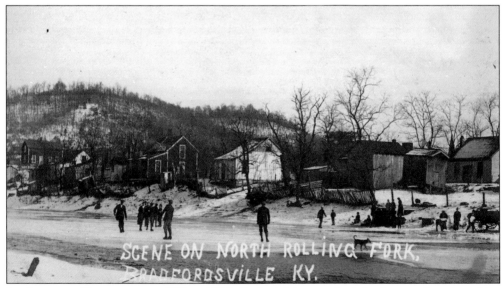

ICE SKATING IN BRADFORDSVILLE, KY, *c.* **1920.** Both children and adults frequently enjoyed ice skating on the frozen north fork of Rolling Fork River just below the bridge each winter in Bradfordsville as reflected in this real photo image.

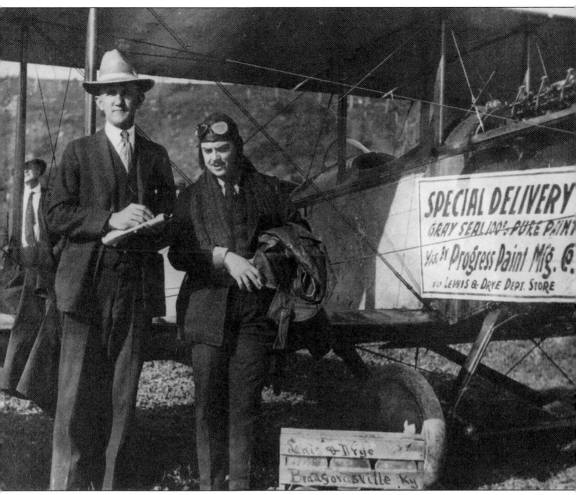

First Air Freight Delivery in Marion County, KY, 1919. Disappointed spectators at Bradfordsville's First Community Fair, sponsored by Lewis & Drye Department Store, questioned the advertisement of the first freight delivery by aeroplane to Marion County, scheduled for October 31, 1919, after the plane did not arrive that day. A second advertisement, in the next issue of *The Lebanon Enterprise*, assured the public, "The Aeroplane Is Coming!" and expressed the regrets of the sponsors, Lewis & Drye and the Progress Paint Mfg. Company of Louisville. A large crowd was awaiting the promised delivery, "right from the clouds to the ground," of a case of Gray Seal Paint. Plane rides were offered to customers who would make major purchases of paint or dry goods from the store. Store owner Don V. Drye stands next to the aviator in the picture.

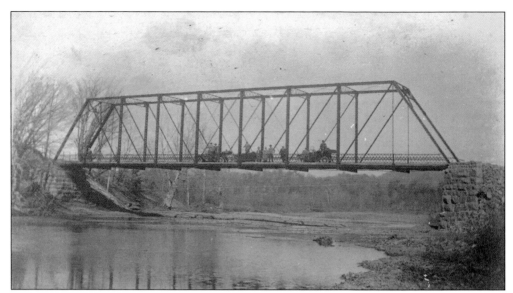

BRADFORDSVILLE BRIDGE, 1911. In the spring of 1911, the Marion County Fiscal Court contracted with the Empire Bridge Company to build a bridge over the Rolling Fork River in Bradfordsville. The citizens of Bradfordsville were required to raise $2,500 of the $4,000 cost. This picture shows the MCFC members inspecting the bridge. An appreciation dinner and fish fry was given for the MCFC members and the contractors. George Collins, president and owner of the Empire Bridge Company of Lexington, KY, was among those in attendance.

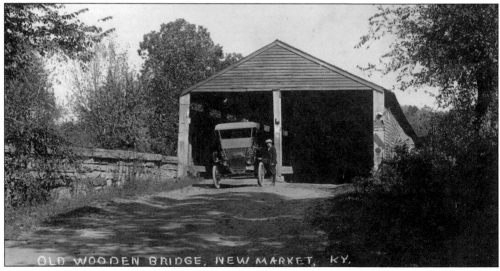

WOODEN BRIDGE AT NEW MARKET, KY, *c.* 1910. In late July 1862, Union soldiers were sent to guard a bridge over Rolling Fork River at this spot because Gen. John Hunt Morgan and his brigade were reported to be in the neighborhood. The soldiers took up the planks from the floor to prevent the Confederates from crossing. They held them off for a short time and withdrew after a short fight. Morgan replaced the planks and "crossed with dry feet." This is a two-lane wooden bridge, typical of many built in Kentucky in the 1800s, and has since been replaced by a metal span.

Three

NELSON COUNTY

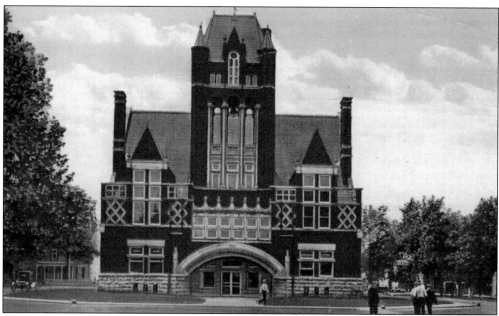

NELSON COUNTY COURTHOUSE, c. 1920. Nelson County, formed in 1785 from southern Jefferson County, was named in honor of Virginia governor and Revolutionary War general Thomas Nelson. The courthouse was built in 1892 at a cost of $33,000 to replace a Georgian-style stone courthouse that had been in use since the 1790s. It was built to contain the county offices and records, as well as to provide a large meeting room for the court. A reception was held in this room for William Jennings Bryan in 1897. The building to the left was the home of Dr. Alfred Hynes, who operated a Union recruiting site there during the Civil War.

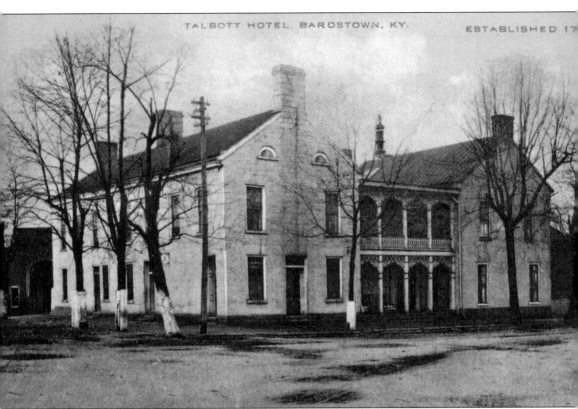

TALBOTT HOTEL C. 1915. A stone-and-brick building on the court square in Bardstown has welcomed travelers since the late 1700s. Called many names—Hynes House, Shady Bower Hotel, Newman House, and, after 1912, the Talbott Hotel—it was operated by George Talbott from 1885 until his death in 1912. A stagecoach stop in the 19th century, it was a popular stop in 1914 for the "automobilists" who toured the Kentucky countryside. Its walls have sheltered the famous and infamous. A brick livery stable (back left) was built about 1885. Hacks, buggies, and horses could be hired and guests' horses stabled while they stayed overnight. Tall tales about cock fighting and poker playing in the stable abounded. Some said that cold weather drove the cock fights into the lobby. A garage replaced the livery stable in 1920. On March 7, 1998, a fire destroyed the roof and upper part of the second floor of the hotel. The rest of the structure suffered water and smoke damage. Eighteen months later, and after extensive repairs, it reopened.

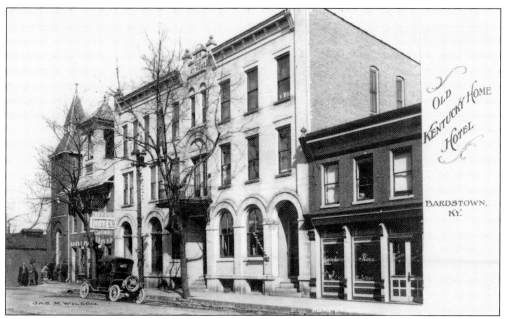

OLD KENTUCKY HOME HOTEL, *c.* **1920.** The Mansion House, built in 1842, was demolished in 1914 to make room for this building on North Third Street, called the Old Kentucky Home Hotel. The older hotel-saloon was also known as The Central Hotel and The Bardstown Hotel. The long shed building beyond the Christian church on the left is the livery stable where a Civil War skirmish took place in 1863. This hotel was torn down in 1971.

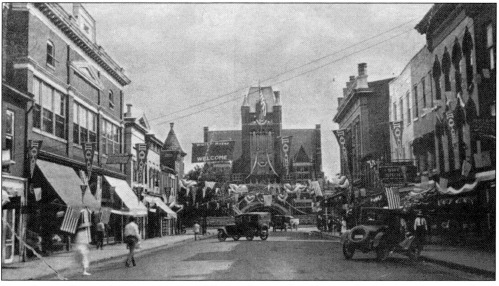

MAIN STREET SCENE CONVENTION, *c.* **1920.** Bardstown has the "Welcome Banners" out for a convention or auto rally. Notice the Sweete Shoppe sign on the right. Banquets, meetings, and dances were held there when groups such as the American Legion convention, the Kentucky Fox Hunters Association, and guests of the John Fitch monument unveiling came to town. On the left is the Crystal Building where Uncle Joe's Place, a liquor store, the Crystal Movie Theatre, and George Mann's undertaking business were located.

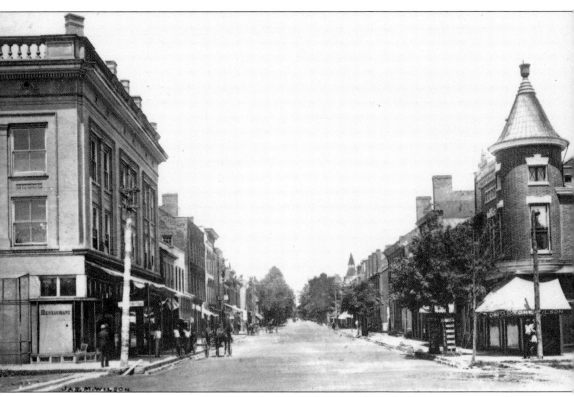

MAIN STREET LOOKING NORTH, *c*. 1909. Cincinnati photographer Albert Kraemer captured this view of Bardstown's Main Street as seen from the court square in 1909. On the left is the nine-year-old Johnson building, with drugstore and grocery on the first floor and offices and apartments on the upper floors. On the right is James M. Wilson's new drugstore. Wilson published many postcards of the area and used one similar to this one for advertisement purposes. A jewelry store, barbershop, and dry goods business were located in the next building. The third building is the Wilson & Muir Bank on the alley. Next door, the chimneys of the McAtee Hotel rise above the roof line. The hotel was torn down in 1911 to make room for the three-story building, which housed several businesses and the Crystal Theatre. The exterior of the Wilson Drugstore building was greatly changed in 1924 when Farmers Bank renovated it for its use. In 1970, the bank moved into a new building one block away. The building on the corner is still in use.

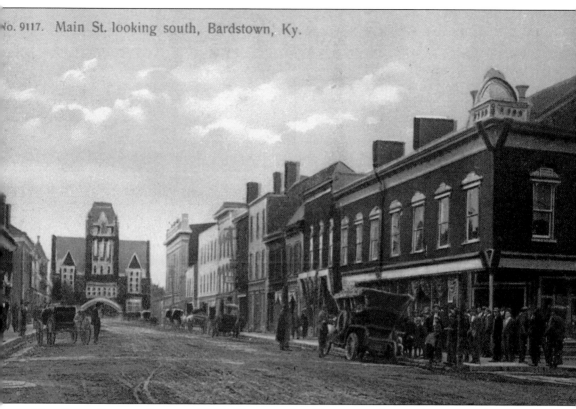

No. 9117. Main St. looking south, Bardstown, Ky.

MAIN STREET LOOKING SOUTH, C. 1909. Photographer Kraemer took two pictures on the same day in 1909, capturing a moment in time in Bardstown. This view of Main Street looking south from the intersection of Flaget Avenue shows unpaved streets and few automobiles. At right is the Wood & Crume Drugstore, as the mortar and pestle on the roof advertises. An automobile, thought to be owned by Congressman Ben Johnson, has drawn a crowd. Could Mr. Johnson be reporting on his Congressional successes? Next door in the same building as the drugstore were a telegraph office and a dry goods store. The third building was Spalding & Sons Dry Goods, a business in Bardstown since 1856 with a photography studio on the second floor. On the left is the east side of Main Street. There were several saloons and poolrooms in the middle of this block. Ladies chose to walk on the other side where dry goods, groceries, and hat shops flourished. Banks were on the east side, also, but could be reached from each corner without passing "those saloons."

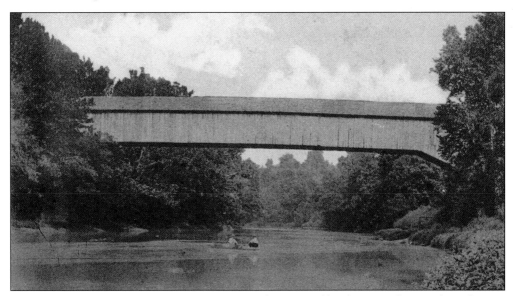

WOODEN BRIDGE OVER THE BEECH FORK, C. 1910. The covered bridge over the Beech Fork River on the Bardstown-Green River Turnpike was rebuilt in 1866 after being destroyed during the Civil War. This new bridge was not as wide as the old one, but it was built on the original stone abutments. It was used until 1933 when an iron bridge was constructed upstream. It fell into the river in 1938.

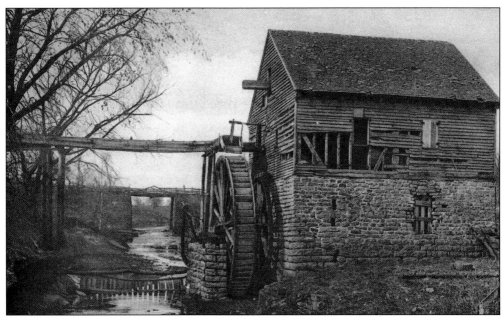

OLD MILL, C. 1900. This is a postcard made from an earlier photograph of the Old Mill in Bardstown. This mill dated to the early 19th century and was a landmark in the community. Purchased by the city of Bardstown in 1901, it was demolished shortly thereafter. In the background, a bridge is pictured over Town Creek. This was the main eastern entrance into town. In October 1862, more than 8,000 Confederate and 15,000 Federal soldiers crossed over this bridge on their way to the tragic Battle of Perryville.

WICKLAND—THE HOME OF THREE GOVERNORS, C. 1920. This is the only home in the United States in which three governors from one family lived in the same house. Charles Anderson Wickliffe, builder of the house, was governor of Kentucky in the 1830s; his son, Robert Wickliffe, was governor of Louisiana just before the Civil War; and his grandson, J.C.W. Beckham, served as Kentucky governor from 1900 through 1907. Built about 1820, it is considered the best example of Georgian architecture in Kentucky.

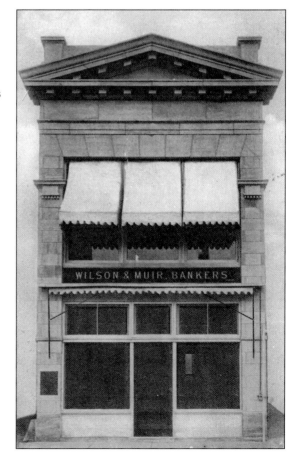

WILSON & MUIR BANK, C. 1910. In 1900, a handsome stone face was put on this building, which had its beginnings as a watch shop before being bought by Richard Shipp in 1865 for use as a bank. The partnership of William Wilson and Jasper Muir became Wilson & Muir Bank in 1869. The interior was remodeled in 1926. A new and larger building replaced this one in 1962.

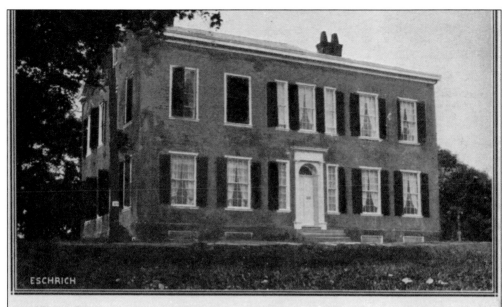

MY OLD KENTUCKY HOME (FEDERAL HILL), THE SHRINE OF STEPHEN COLLINS FOSTER, WHERE HE WROTE HIS IMMORTAL LYRIC, "MY OLD KENTUCKY HOME." IT WAS BUILT SOON AFTER 1795 BY JUDGE AND U. S. SENATOR JOHN ROWAN, KINSMAN OF FOSTER. THIS PICTURE WAS MADE ON DAY OF DEDICATION, JULY 4, 1923.

DEDICATION OF MY OLD KENTUCKY HOME, JULY 4, 1923. After a three-year fund-raising effort by the Old Kentucky Home Commission, the plantation was purchased from Madge Rowan Frost to be preserved in memory of her cousin, Stephen Foster. After extensive renovation, a dedication ceremony was scheduled on Foster's birthday. A stream of traffic came into Bardstown from all directions to dedicate the home, which inspired Stephen Foster to compose the song adopted by Kentucky in 1928 as its state song. A special train from Louisville carrying 441 people arrived at the depot and another 6,000 automobiles were directed to the festivities by special traffic officers sent from Louisville for that purpose. Foster melodies and patriotic airs were played by the 10th Infantry Band from Camp Knox after they marched through town (below) to Federal Hill plantation.

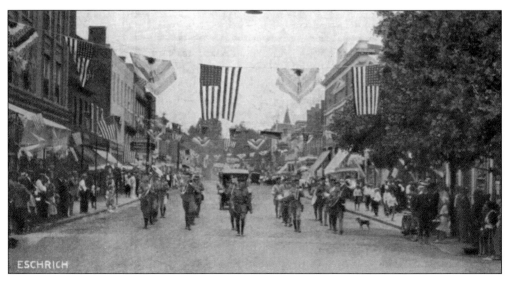

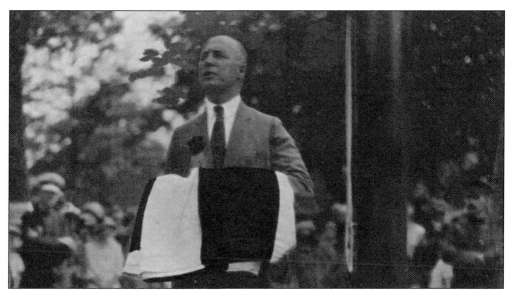

GOV. EDWIN P. MORROW AT MY OLD KENTUCKY HOME, JULY 4, 1923. A delegation of Foster relatives and dignitaries from Pittsburgh, Foster's home, was recognized by the master of ceremonies, Arch Pulliam. Representing the Old Kentucky Home Commission, he presented the shrine to Gov. Edwin P. Morrow, who accepted it, calling it ". . . one of Kentucky's treasures." Morrow also recognized the gift of a portrait of Foster sent by the Pittsburgh Chamber of Commerce.

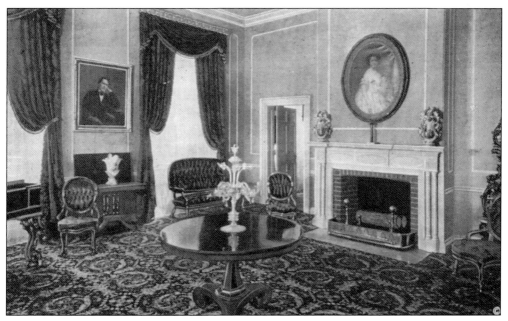

LIVING ROOM, C. 1930. Mrs. Frost's Victorian-style furniture is displayed in the redecorated parlor of Federal Hill. The portrait on the left, a gift of the Pittsburgh Chamber of Commerce, is of Stephen Foster. The painting hanging over the mantel is one of two "Johnson Sisters" whose first names are unknown. Family paintings, furniture, books, and bric-a-brac were purchased with the house in 1922.

69

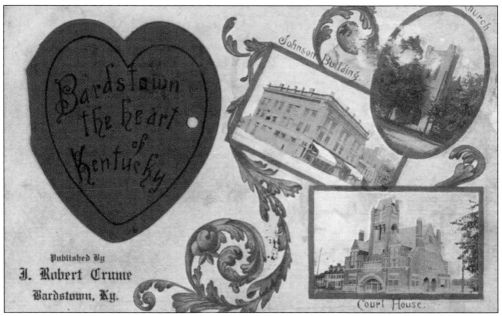

ADVERTISING CARD, 1907. "Bardstown the heart of Kentucky" reads the notation on the red heart of this postcard. This unusual promotional card was copyrighted by Glazier Art Company of Boston, MA, in 1907. J. Robert Crume, local druggist, paid for the publishing. When the heart is opened, an accordion of ten pictures unfolds that depicts historical and natural attractions of the area.

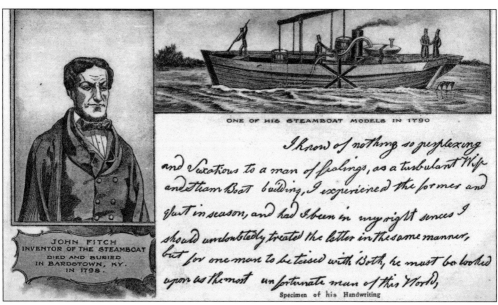

POOR JOHN FITCH, C. 1925. A monument to the inventor of the steamboat, Connecticut native John Fitch, was unveiled in Bardstown on May 25, 1927. Mrs. Ben Johnson documented the claim and lobbied Congress to finance the monument to honor this Revolutionary soldier who was buried in Bardstown. This card reveals his frustrations in marriage and inventing.

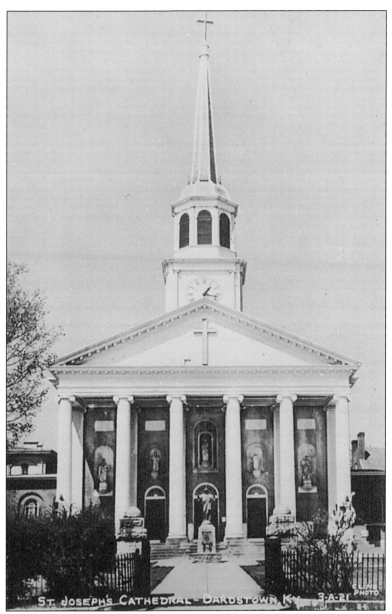

St. Joseph's Church—The First Cathedral West of the Alleghenies, c. 1915. This church was built between 1816–1819 by Bishop Benedict J. Flaget. John Rogers, formerly of Baltimore, was the architect and supervised the construction. The large interior columns are solid poplar tree trunks covered with plaster and painted to simulate marble. The paintings on the walls, gifts of King Francis I of Sicily and Pope Leo XII, have hung in the church since the 1820s. The original wood floor was covered by terrazzo in 1925. The exterior columns are of brick. The bell tower, steeple, and front porch were added a few years after its consecration in 1819. The iron fence is a later addition and connects into a stone fence on each side. The cathedral served as the seat for the Diocese of Bardstown from 1819 until 1841 when Flaget moved it to Louisville. Two buildings of St. Joseph College can be seen directly behind the church.

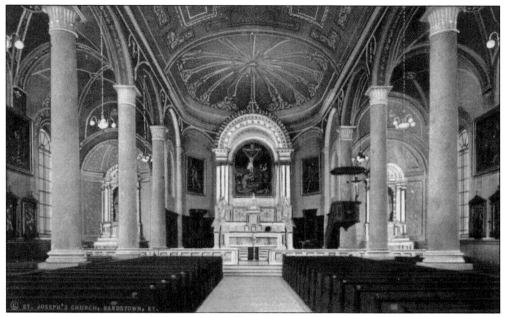

INTERIOR OF ST. JOSEPH'S CHURCH, C. **1925.** The interior of the church has undergone many changes since its construction in 1816. The renovation of 1879 added the elaborate wooden altars and the ceiling painting. The bishop's throne on the left and the elevated pulpit on the right were retained from the earlier church. The original stone altar was removed by dropping the 3,000-pound, 10-foot-long stone below the floor of the sanctuary. Electric lights were installed in 1910 to replace kerosene lamps. The marble altar rail was also installed in the early 1900s.

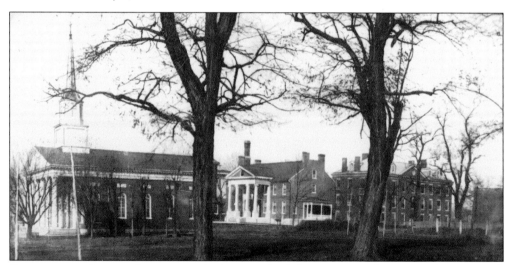

CATHEDRAL AND COLLEGE COMPLEX, C. **1920.** From the left are St. Joseph Cathedral, built 1816-1819; the rectory, built in 1819; and Spalding Hall of St. Joseph College, built in 1826. At the right is the brick wall of the college handball court, built in the 1850s. Handball was a popular sport at that time. The local brick maker who constructed the wall soaked all the hand-made bricks in water before laying them. The wall stood for more than 70 years until it was taken down.

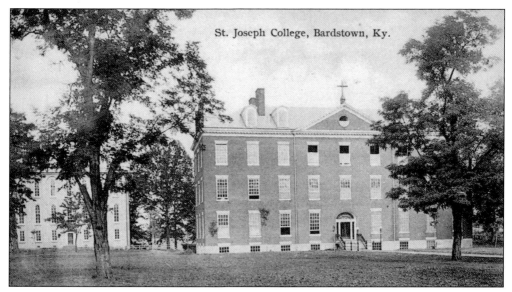

St. Joseph College, Bardstown, Ky.

ST. JOSEPH COLLEGE, C. 1915. Founded by Bishop B. J. Flaget in 1820, St. Joseph College was a successful boarding school attended by young men from throughout the South. Spalding Hall (right) was built in 1826 by the local clergy who were operating the school. Flaget Hall (left) was built in 1852 by the Jesuits who operated the school from 1848 to 1868. During the Civil War, this building was leased for 15 months by the federal government as a hospital for soldiers. An orphanage, a seminary, and, from 1911 to 1968, a preparatory school run by the Xaverian Brothers, utilized these buildings.

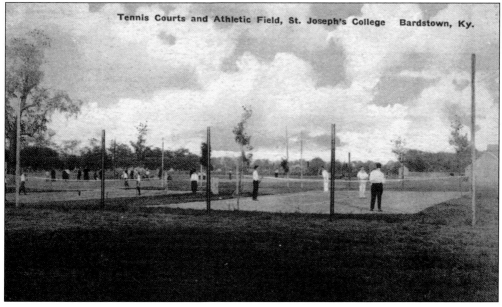

Tennis Courts and Athletic Field, St. Joseph's College Bardstown, Ky.

TENNIS COURTS AND ATHLETIC FIELD, ST. JOSEPH COLLEGE, C. 1920. St. Joseph College reopened in 1911 under the supervision of the Brothers of St. Xavier. Sports were encouraged and cross-town competition with Bardstown High School athletes made exciting news stories. This view is of the tennis courts directly west of the gym. In the background are the football goal posts.

73

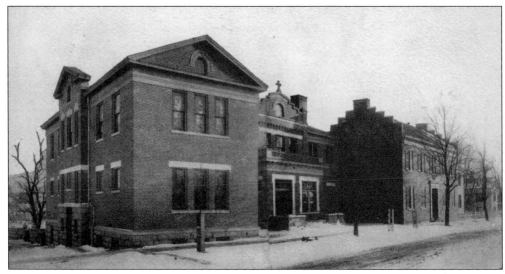

BETHLEHEM ACADEMY, C. 1920. Bethlehem Academy was opened by the Sisters of Charity in 1819 on the southeast corner of Fifth and Graves Streets. The brick section to the right is the original house purchased from Nehemiah Webb in 1819. A later frame addition on the south enlarged the school. In 1910, a large brick wing was constructed on the north, which is the section to the left. It served as an elementary school and a girls' high school until 1953, when the elementary grades moved into a new school. A new high school was constructed in 1959 and this building was demolished in 1963.

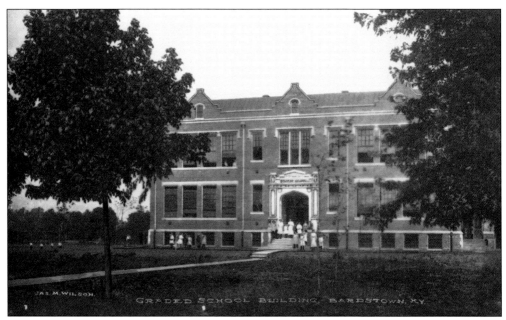

BARDSTOWN GRADED SCHOOL, C. 1915. This building was erected on North Fifth Street in 1908 at a cost of $30,000 by the Bardstown Independent School District. Made of stone and brick, it offered eight lower grades and four years of high school. Increased enrollment created the need for a new high school building, which was built in 1927. Both of these buildings were demolished in the 1960s after the present schools were constructed.

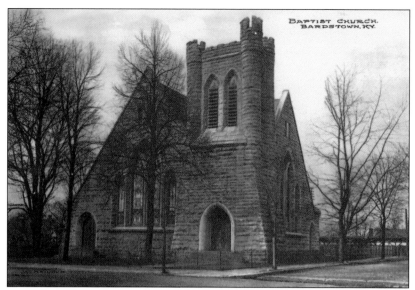

BARDSTOWN BAPTIST CHURCH, C. 1915. E. Baker Smith, a local architect and builder, designed and built the Bardstown Baptist Church in 1892. This postcard view, taken about 1915, shows the iron fence enclosing the church yard and the horse shed which extended across the back of the lot.

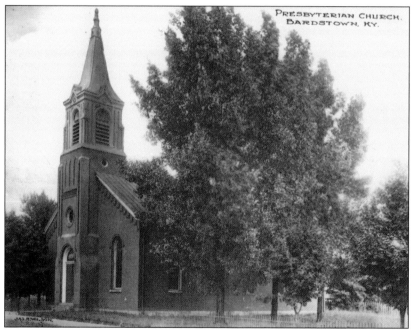

BARDSTOWN PRESBYTERIAN CHURCH, C. 1915. In 1825, Charles A. Wickliffe sold a lot to the Presbyterian congregation for $200 and free pew rent. The Bardstown Presbyterian Church was built in 1827. Wickliffe lived another 40 years and didn't have to pay pew rent for the entire period! Rev. Terah Templin, founder of a number of Kentucky Presbyterian churches, was a frequent visitor to the early congregation. He died in Bardstown and was buried in the Presbyterian cemetery.

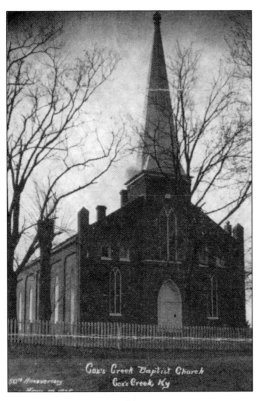

COX'S CREEK BAPTIST CHURCH, C. 1930. Baptists had met for worship in this neighborhood since 1784. This became the third church when it was dedicated in 1871. It was completely destroyed by a tornado in 1942. Only the organ was recognizable in the wreckage. The church was rebuilt and is still used for weekly worship.

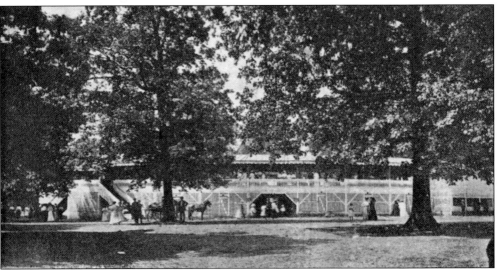

AMPHITHEATER AT NELSON COUNTY FAIRGROUNDS, C. 1914. The Nelson County Agricultural Association held successful fairs since its organization in 1856. The 1887 amphitheater was used for horse, mule, and cattle shows. Agricultural displays were exhibited in the Floral Hall. By 1902, automobile and bicycle races competed for the attention of horse racing fans. Fair Week was in the month of September with patrons arriving on trains and carriages from all over the area. Located near the railroad, the fairgrounds were 1.5 miles north of Bardstown on the Louisville Turnpike near Nazareth.

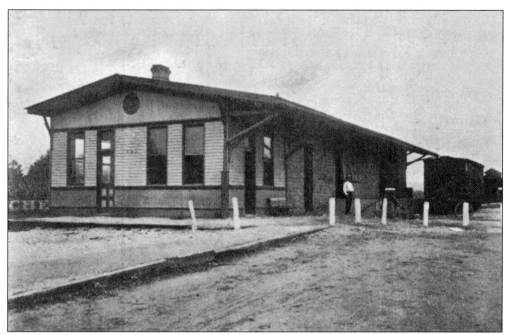

BARDSTOWN RAILROAD DEPOT, C. **1906.** The Bardstown and Louisville Railroad Company began building a branch line to connect with the main L&N rail line in 1856. Soon running out of funds, it contracted with L&N to finish the line and operate it. This stone-and-frame depot was completed in 1860 and used for both passengers and freight until 1953. Civil War guerrillas threatened to burn it to the ground in 1864, but were dissuaded by a depot agent when he presented them with "some fine old whiskey and some jars of delicious pickles." The building is still in use today as a private railroad depot.

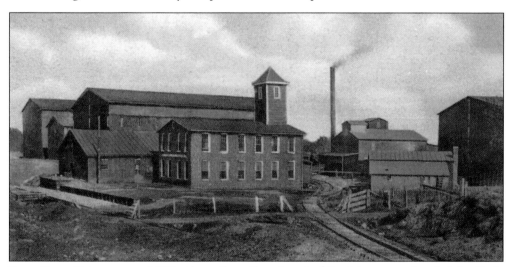

EARLY TIMES DISTILLERY, C. **1915.** Along the railroad east of Bardstown was located the Early Times Distillery. Built by John H. Beam in the late 1890s, it is pictured here in a 1915 view. Closed during Prohibition, it reopened in 1935. It was also known as the J.T.S. Brown & Son Distillery and continued to distill spirits until 1950. It stored whiskey until it closed in 1962.

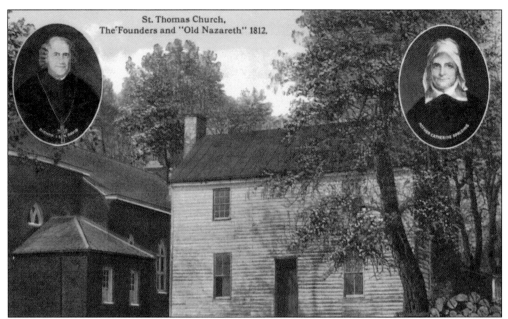

ST. THOMAS CHURCH, THE FOUNDERS AND OLD NAZARETH **1812**, C. **1910.** On the left is the rear of St. Thomas Church, completed in 1816 near Bardstown by the first bishop, Benedict J. Flaget. It was modeled after St. Mary's Church in Baltimore, MD, and is the first building of gothic design in Kentucky. In the log structure in the middle were founded the St. Thomas Seminary in 1811 and the Sisters of Charity of Nazareth in 1812. Pictured are Bishop B.J. Flaget and Mother Catherine Spalding.

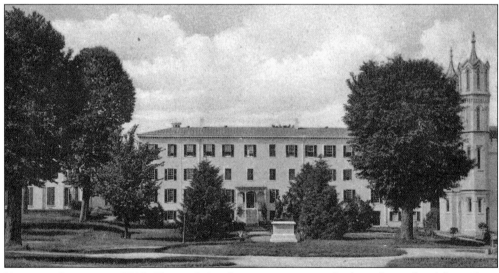

NAZARETH CONVENT, C. **1900.** Nazareth Academy, a convent and a boarding school for girls in Bardstown, was operated on this site by the Sisters of Charity since 1822. This three-story structure, erected by Mother Catherine Spalding prior to the Civil War, was torn down in 1904 and a new convent and administration building was constructed. The wrought-iron porch was preserved and moved to another entrance. The tower at right is the St. Vincent De Paul church, built in 1854.

MONSIGNOR FALCONIO, APOSTOLIC DELEGATE, NAZARETH, KY, SEPTEMBER 13, 1911. Nazareth's petition to become a Papal Institute was granted in 1911. Monsignor Diomede Falconio came to Bardstown and opened St. Joseph College for the Xaverians on September 12, 1911, and visited Nazareth the next day. The above view is of the front porch of the six-year-old Motherhouse, decorated in Papal colors of purple, gold, and white, with the academy graduates lined along the steps. The rest of the school was assembled close by. On the left of the porch is the academy orchestra. In procession through the buildings, they visited all the areas. The three views at the bottom show, at top, Rev. C.J. O'Connell of St. Joseph Cathedral, an unidentified churchman, Mgr. Diomede Falconio, and Rev. Richard Davis, the Nazareth chaplain. In the lower left view, the novices and postulants flank the dignitaries, and, at right, the carriage leaves on the main avenue. Falconio was made a cardinal shortly afterward and returned to Rome.

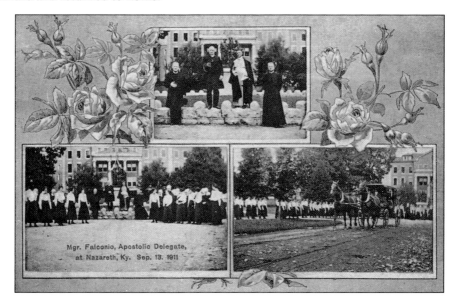

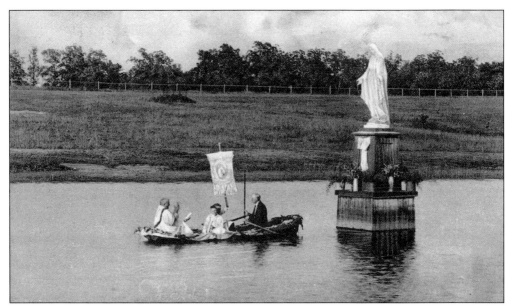

BLESSING OF THE IMMACULATE CONCEPTION STATUE, AUGUST 15, 1922. Father Richard Davis blessed the newly completed Immaculate Conception Lake and Statue. This portion of the ceremonies occurred when 500 representatives of the International Federation of Catholic Alumnae visited Nazareth by special train during the Fifth Biennial Convention meeting in Louisville.

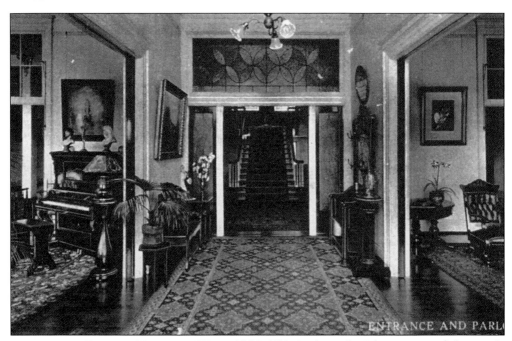

ENTRANCE AND PARLORS, NAZARETH, KY, C. 1910. This is the colonial entrance of the newly built Motherhouse. These formal parlors were used by family and friends of the academy, students, and novices for Sunday afternoon visits. Strict schedules ruled the lives of the students and novices. The piano was used during the visits to reveal musical progress.

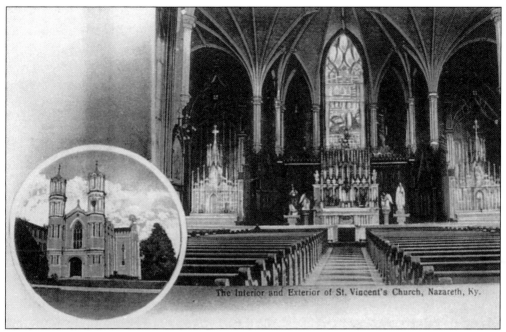

The Interior and Exterior of St. Vincent's Church, Nazareth, Ky.

St. Vincent de Paul Church, Nazareth, KY, c. 1905. The church was constructed in 1854 and remodeled in 1924 and 1972. This image displays the ornate ceiling with its groined arches and fan vaulting. One of the original stained-glass windows is in the front wall between the two towers. There is a clock in the tower on the right.

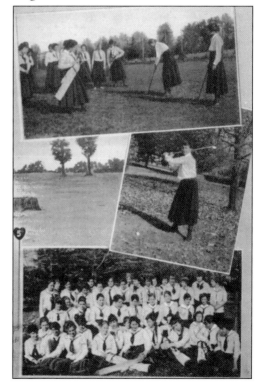

The Golf Club, Nazareth, KY, c. 1912. Rev. Richard Davis, an avid golfer, created the golf course. He played a daily golf game with his dog, Spencer, as a companion. The physical education teacher was in charge of golf instruction for the girls. Intramural games of golf and tennis were played and trophies were awarded during the commencement. The golf links "died" in 1944.

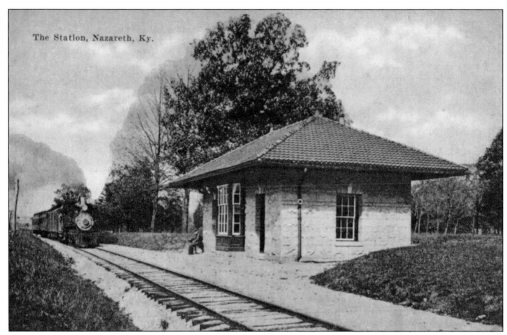

The Station, Nazareth, Ky.

THE STATION, C. 1910. In 1857, Nazareth supported the extension of railway service to Bardstown by buying stock in the Bardstown and Louisville Railroad Company. The road was completed in 1860 and operated by the L&N Railroad. Daily passenger trains allowed the Sisters of Charity and academy students to travel from Louisville and ride into Bardstown, 2 miles away. Nazareth constructed this depot in 1907, at a cost of $4,367, with L&N contributing only $400.

TOMB OF JEROBOAM O. BEAUCHAMP AND WIFE, BLOOMFIELD, KY, C. 1910. Jeroboam Beauchamp and his wife, Anna, are buried under this stone in the same coffin. To avenge her alleged seduction by Col. Solomon Sharp, Jeroboam murdered him in Frankfort in 1825. Both Jeroboam and Anna were jailed; she was later released but he was sentenced to hang. At her request, Anna was permitted to join her husband in his jail cell whereupon they attempted suicide by stabbing themselves. She died but he lived to be hanged.

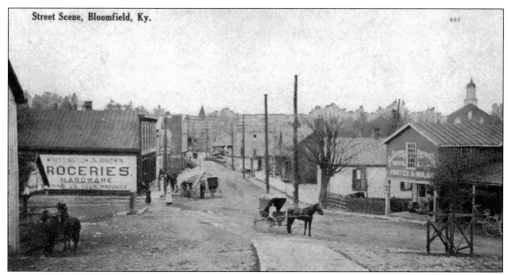

STREET SCENE, BLOOMFIELD, KY, C. **1910.** This view looks east from where the Fairfield-Louisville road intersects the Bardstown Pike. On the left is Whittington & Brown Groceries and Hardware. Across the street is Porter & Nolan, a produce and meat store. The spire of the Baptist church on the Springfield Pike is on the right. In the center is the bridge over Simpson Creek.

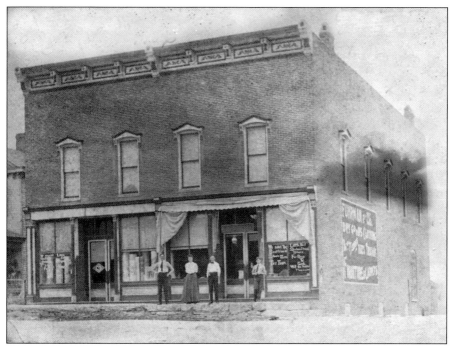

FUHRMAN & CO. STORE, BLOOMFIELD, KY, C. **1906.** The Simon Fuhrman family stands in front of the Fuhrman & Co. general merchandise store. Simon Fuhrman purchased the store from M.&H. Judy, a firm that had operated it for more than 25 years. Renamed Fuhrman & Co. General Merchandise, it carried clothing for all the family, furniture, and carpets for the home, and trunks and valises with "four clerks ready to serve you."

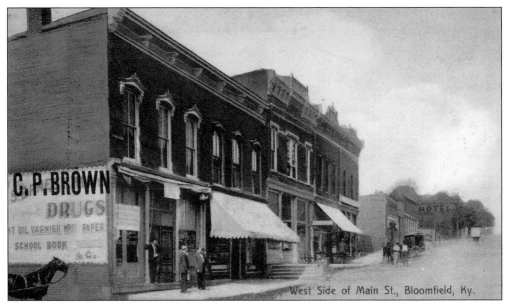

WEST SIDE OF MAIN STREET IN BLOOMFIELD, KY, C. 1909. This view reveals an overprint on the postcard of the drugstore wall sign. In 1904, Lynch Drugstore occupied this corner. Later, in the 1920s and 1930s, it was the Plock Drugstore. Continuing up the street is the Muir Building, built in 1894, where Hardesty Dry Goods advertised its sales with red wrapped parcels. Next door is the Citizens Bank of Bloomfield, established in 1890. The last building was the Bloomfield Hotel, owned by S.S. Bishop and operated by Charles McClain. On August 5, 1912, it was destroyed by fire.

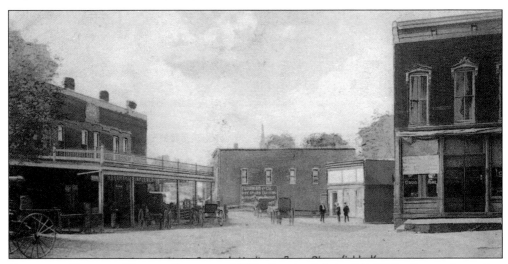

CORNER OF MAIN AND MADISON STREETS, C.1909. On the left is C.P. Wells Store. Groceries, hardware, tin, stoves, and building materials were sold in this store. In the middle of the view, across the bridge over Simpson Creek, is Fuhrman & Co. General Merchandise store. It began in 1894 when it was purchased from M.&H. Judy, a firm which operated here for 25 years. The Lynch Drugstore, on the right, began business in 1879. Its soda fountain was a popular spot in 1904, advertising that it "specializes in paints and wallpapers as well as a complete line of drugs."

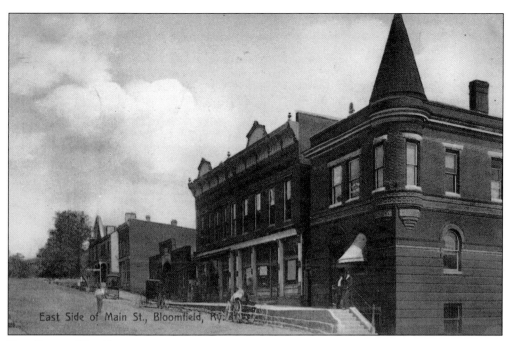

East Side of Main St., Bloomfield, Ky.

EAST SIDE OF MAIN STREET IN BLOOMFIELD, KY, C. 1909. The corner building with the turret is the new Muir, Wilson & Muir Bank. Next door is the Ash-Farmer store located in the Stocker & Finn Building. A 1904 advertisement states that they are ". . . clothiers, dealers in gents' furnishings, dry goods, shoes, hats, trunks and valises." In the same building is A.C. Knob Groceries. An advertisement reads, "They carry a nice line of china, glassware, staples and fancy groceries and buggy and wagon harnesses." A livery stable can be seen up the street with the large door opening.

MUIR, WILSON & MUIR BANK, BLOOMFIELD, KY, C. 1909. The Muir, Wilson & Muir Bank opened in 1876 as a branch bank and received its charter in 1909. The bank offices were on the first floor with Dr. J.J. Wakefield's office on the second floor. The buggy shown in the image is believed to be Dr. Wakefield's. He made house calls with Lady Jane Grey (his horse).

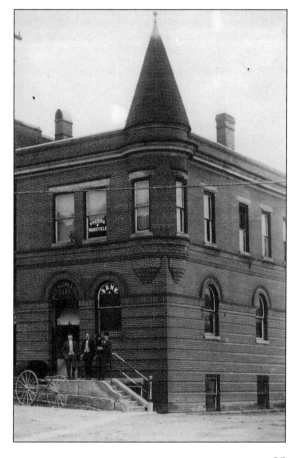

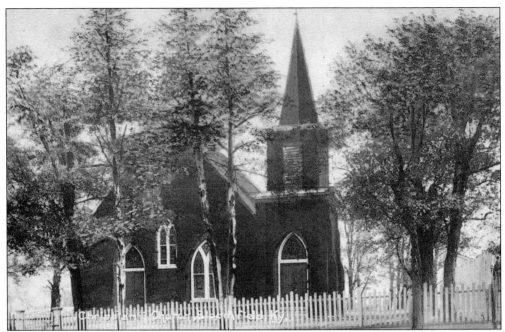

BLOOMFIELD CHRISTIAN CHURCH, C. 1910. The Bloomfield Christian Church is located on the Taylorsville Pike next to the cemetery. It was erected in 1849 and remodeled in 1896.

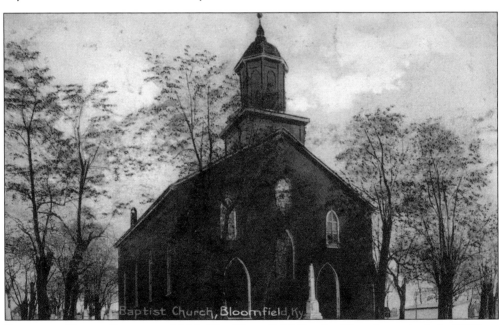

BLOOMFIELD BAPTIST CHURCH, C. 1910. The Bloomfield Baptist Church was built in 1827 on the Springfield Pike. It was damaged by a tornado in 1923 and when it was repaired, the design was drastically revised. The monument to Rev. William Vaughn, pastor from 1837 to 1869, was then removed from the front and relocated on the side. This building had also suffered damage during the Civil War. Its congregation petitioned the government for payment of claims, but to no avail.

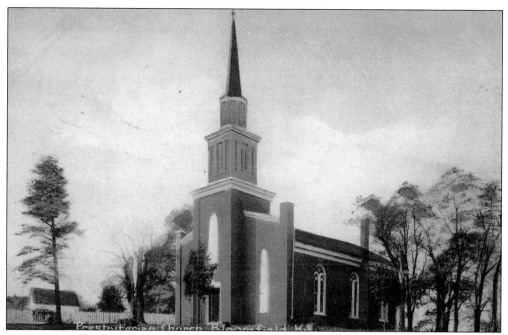

PRESBYTERIAN CHURCH, BLOOMFIELD, KY, C. 1910. This church is located behind the Masonic Hall on the Fairfield-Bloomfield Pike. It was built in 1852, renovated in 1896, and destroyed by fire in 1956. Some of the materials were salvaged and used in the building of the new church in 1958.

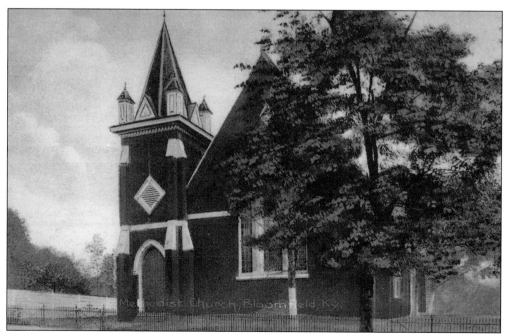

METHODIST CHURCH, BLOOMFIELD, KY, C. 1910. The first Methodist Church of Bloomfield was built in 1851 on land donated for the church by Mrs. Samuel B. Merrifield. In 1881, this building, located on Main Street, replaced the earlier church.

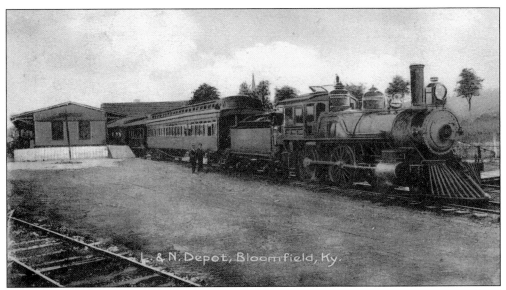

THE L&N DEPOT, BLOOMFIELD, KY, C. **1910.** The Louisville, Cincinnati & Lexington Railway Company completed the tracks to Bloomfield from Shelbyville in 1880. This 27-mile branch line provided for shipment of agricultural products from the area. The Louisville & Nashville Railroad bought out the L.C.&L. on November 1, 1881. Traffic on the railroad never developed sufficiently to support the expense and, on October 10, 1952, the final run was made on this line. The train depot is now used as offices for city government and a library.

WAGONS ON DEPOT STREET, C. **1911.** These tobacco-loaded wagons, lined up along Depot Street, were ready for the auctioneers. This was the first loose-leaf tobacco market in Bloomfield. The large dark building on the right was the warehouse of J.D. Merrifield, who was in the farm implement and grain storage business. On the left is a row of section houses built for the railroad employees. The depot can be seen down the street.

FUHRMAN & CO. ADVERTISEMENT, BLOOMFIELD, KY, C. 1910. In the early 1900s, Simon Fuhrman owned and operated a general merchandise store in Bloomfield that became Fuhrman & Co., one of the largest wholesale and retail establishments in Nelson County. He frequently displayed, on picture postcards, examples of the latest styles of men's clothing that he purchased during his annual trips to St. Louis, Chicago, and various eastern markets.

J.W. SHIRLEY ADVERTISEMENT, BLOOMFIELD, KY, C. 1912. Advertising postcards such as this were typically used by store owners to invite potential patrons to their place of business. The advertiser would often display and describe the virtues of his product on the postcard. Shirley's jewelry business in Bloomfield included a fine line of diamonds, watches, jewelry, clocks, and silverware. He was also an optician with a specialty of fitting and adjusting eyeglasses in his store.

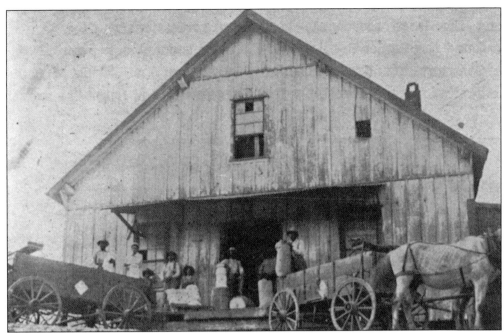

Water Power Mill, Chaplin, KY, c. 1904. This mill, built in 1870 by Mt. Washington residents H.J. Barnes and Richard Weaver, was situated on the Chaplin River near the bridge on the Chaplin and Willisburg Turnpike. The leading brands of flour it produced were the Kentucky Star and Center Shot. The mill was operated by waterpower about ten months of each year and by a 35-horsepower Atlas engine and boiler when there was insufficient power for grinding purposes.

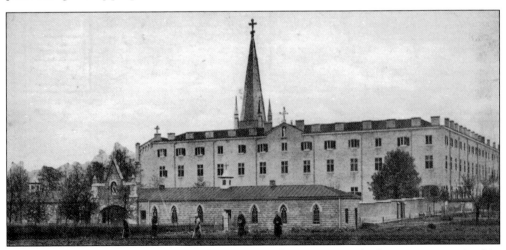

Abbey of Gethsemani, c. 1920. In 1848, a group of Trappist monks from France arrived in Nelson County to build a monastery, the first in the United States. This postcard shows the main entrance to the Abbey of Gethsemani. The entrance was demolished in 1988. This was the home of famous philosopher-writer Thomas Merton. For many years, it was closed to the public except for church worship. Now the Cistercian monks provide retreats for men and women. They support their monastery by producing and marketing fruitcakes, cheese, and candy.

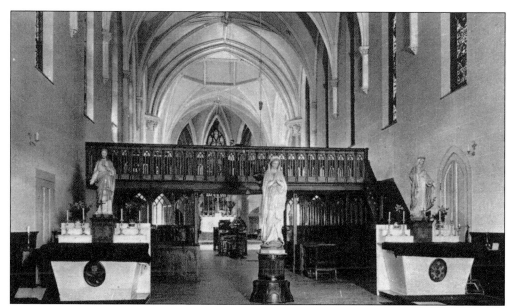

CHURCH INTERIOR AFTER RENOVATION, C. **1924.** This is the interior view of the church taken from the Brothers' choir at Our Lady of Gethsemani Abbey. A series of postcard views were made of the monastery in the 1920s showing interior rooms not open to the public. The church was remodeled in 1924 and the plaster walls between the secular section and the choir were removed as shown in this view. Most of the Victorian details shown were removed in the 1960s remodeling.

DOM OBRECHT'S OFFICE, C. **1924.** Dom Edmond Obrecht, abbot of Gethsemani from 1898 until 1935, is pictured in his office with some of the 400 Madonnas in his collection. Under his leadership, they renovated old buildings and constructed new ones needed for the growth of the monastery. He was an avid collector of historic relics and was able to encourage significant literary contributions to the library and museum of the abbey.

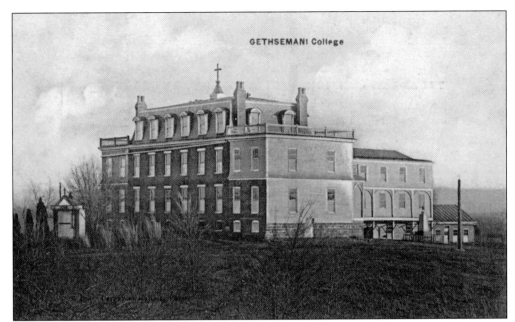

GETHSEMANI COLLEGE, C. 1905. This view of Gethsemani College was taken before 1912 when the building burned. This was a boys' school operated by the monks at the Abbey of Gethsemani in the 1890s and early 1900s. Abbot Obrecht declined to rebuild the school after the fire, ending the Trappist involvement in education in Nelson County.

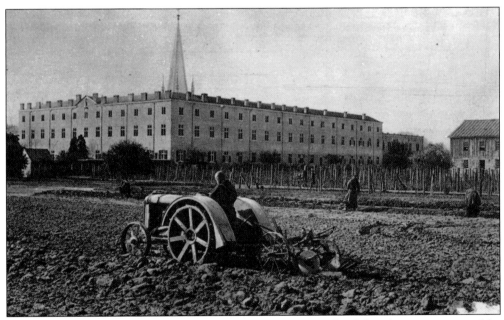

MONKS AT LABOR, C. 1924. The monastery farm provided food for the monastery table. Vegetables were raised for the monks' vegetarian diet. The dairy produced cheese for the monks and for public sale. In front of the wall, grapevines from the vineyard can be seen. The constitution of the order requires that the monks make their living by farming, but the real life of a monk is spent in meditation, prayer, and praise of God.

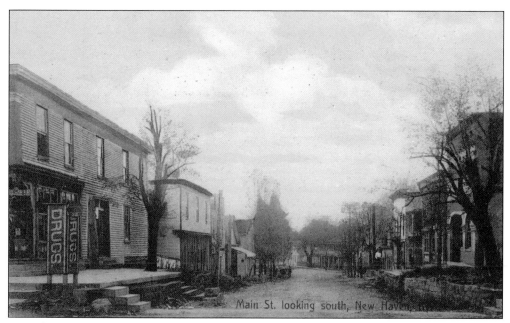

MAIN STREET LOOKING SOUTH, NEW HAVEN, KY, C. 1909. The two-story building at left was originally a hotel, later New Haven Drug Co. (as pictured). It was later operated as a grocery store by different proprietors including Louis Dawson, Joe Smith, Carl Head, and Green Price. Proceeding southwardly from left are the two-story Knights of Columbus building then the two-story Thompson grocery, which had a bowling alley upstairs. Next to the grocery stood Edwin C. Dawson's Dry Goods and Clothing store, followed by Mike Krebs store building. A bank, later a post office, occupied the two-story building at right. Next door is the Ford Building with George Hutchins' Dry Goods store.

METHODIST CHURCH, NEW HAVEN, KY, C. 1905. The Methodist church on Main Street across from St. Catherine's Church was used as a hospital during the Civil War and was destroyed by fire in the 1980s. At right can be seen the Riverview Cemetery.

93

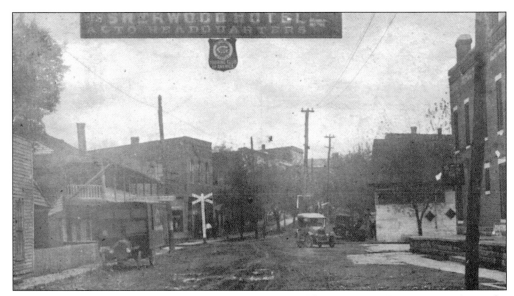

MAIN STREET LOOKING NORTH, NEW HAVEN, KY, C. 1920. The two-story Dawson Hotel is at far left next to the parked truck. Proceeding northwardly down Main Street on the west side of the road are the Allen Drug Store (tall brick building behind RR crossing sign), "Sop" Applegate's Barber Shop, the B.D. Florence Restaurant and Grocery, the Ford Building, New Haven Post Office and the F.M. Hagan Dry Goods Store. The tall brick structure at far right is the Sherwood Hotel and next to it, across the railroad tracks, is a multi-purpose store building with an upstairs residence.

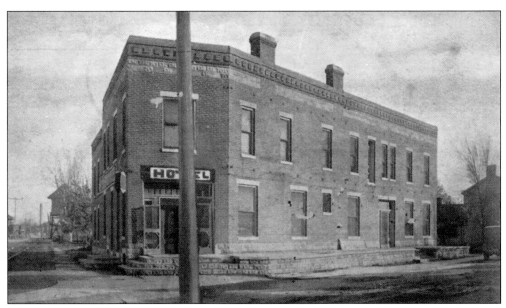

SHERWOOD HOTEL, NEW HAVEN, KY, C. 1915. The Sherwood Hotel, now the Sherwood Inn, has been owned and managed by Thomas Hardin Johnson and his descendants since 1875. "The Sherwood" has fed and lodged untold numbers of travelers and locals who built their lives around the passenger trains that once traversed these tracks. The original two-story frame structure burned in 1913 and was rebuilt on the same site in 1914.

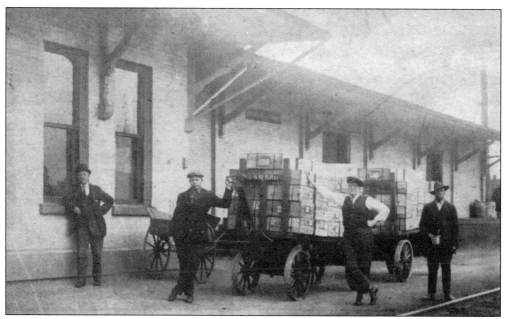

A Sad Scene for Thirsty Boys in New Haven, KY, c. 1920. The caption for this postcard image tells the story. Prohibition had just gone into effect. The cases of whiskey stacked on the two baggage carts had come from an Athertonville distillery located in LaRue County. They were to be sent by rail to the American Medicinal Spirits warehouse in Louisville, ultimately to be used by doctors and druggists for medicinal purposes. Pictured from left to right are Joseph Barry, P.D. Johnson, Edgar Tatum and Herb Mitchell. The left portion of the L&N depot was used as an office and the freight room is at right. The L&N steam engine (below) is pulling a passenger train from Louisville in this early scene. People both arriving at and departing from the depot can be seen in the distance.

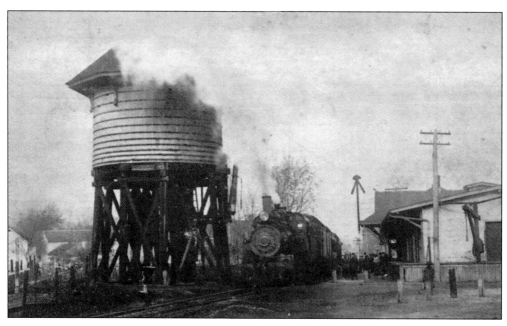

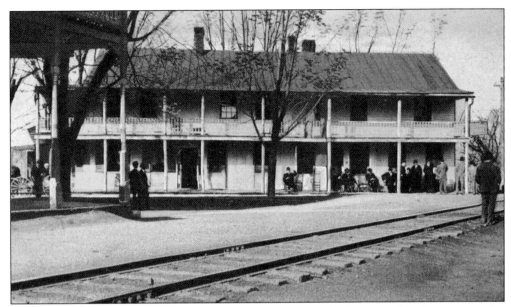

DAWSON HOTEL, NEW HAVEN, KY, C. 1910. For many years, the Dawson Hotel was a popular lodging place for visitors to the area. Salesmen and "drummers" often spent the night here after displaying their wares to, and taking orders from, local New Haven businessmen. Boonie Alvey and his family last occupied the hotel before it was dismantled in 1937. Chester Howard constructed a two-story brick building in its place, and it was then operated as C.F. Howard and Son for many years. Porch posts of the old Sherwood Hotel are seen at left.

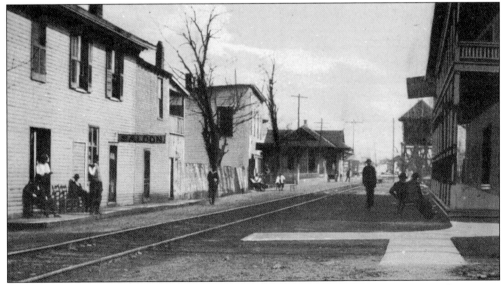

RAILROAD LOOKING EAST, NEW HAVEN, KY, c. 1910. The Frank Boone Saloon is at left. Next to it is a bar with an upstairs residence occupied by the Devers family. At far right is the old Sherwood Hotel. All of these buildings were destroyed by fire on October 1, 1913, which started in the Devers' residence. Five members of the family perished in the fire. In the distance can be seen the L&N depot and water tank.

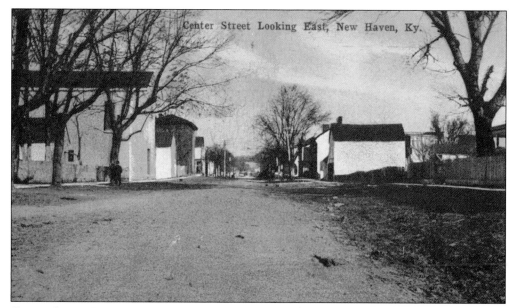

CENTER STREET LOOKING EAST, NEW HAVEN, KY, 1910. The large building at left, a whiskey warehouse, was constructed by Silvester Johnson. For many years, Johnson shipped barrels of whiskey, tobacco, and salted pork on rafts down river as far south as Natchez and New Orleans. After making their deliveries, his employees would often sell or abandon their rafts and walk the entire distance back to New Haven. In later years, this building was converted into an Opera House. The Silvester Johnson bank and residence occupied the third building from left.

MAIN STREET, NEW HAVEN, KY, 1910. The site of the early gasoline pump at far left is the approximate location of one of the town's early water troughs. Next to the troughs was a public well where residents would regularly obtain their drinking water. Confederate general Braxton Bragg and his army drank this well dry as they traveled through New Haven on September 22–24, 1862.

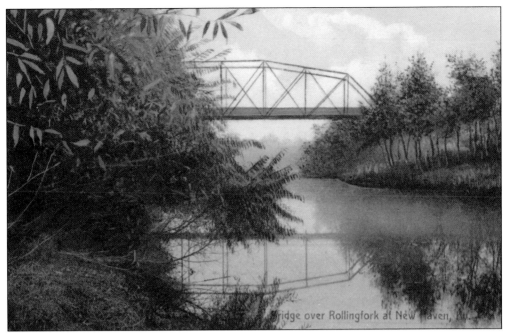

NEW HAVEN BRIDGES, c. 1909. The two-lane iron bridge pictured above connected Nelson County to the left with LaRue County on the right, and was located on what is now Kentucky Highway 52 between New Haven and Lyons Station. The postcard image of the bridge over Rolling Fork River was made by Cincinnati Photographer Albert Kraemer. Many of Kraemer's early Kentucky postcards typically depict bridges, railroad depots, courthouses, churches, river scenes, etc. and are now highly collectible and often historically significant. The railroad bridge (below) is located on the west side of New Haven.

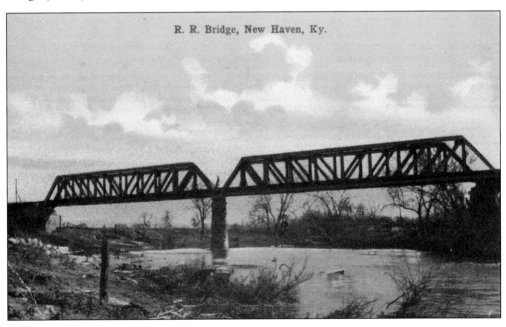

St. Catherine Catholic Church, c. 1909.
This church in New Haven was designed by Abbot Edward of the Abbey of Gethsemani. It is of Roman style architecture and was built under the supervision of Rev. Anthony Viala at a cost of $40,000. It was consecrated in 1887. A disastrous fire in April of 1928 destroyed the church. Fr. James Willett, pastor, continued communion after the fire was discovered and was able to finish the service and evacuate the church, saving all souls and some of the furnishings. Defective wiring caused the fire.

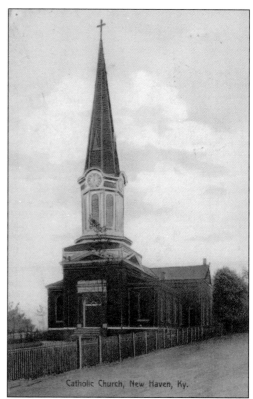

Catholic Church, New Haven, Ky.

New Haven Baptist Church c. 1920.
This church was organized by Dr. W.W. Gardner on April 24, 1887, and dedicated in the spring of 1889. Twenty-two charter members comprised the original congregation. In addition to regular Sunday services, the church had an active B.Y.P.U., Woman's Missionary Society, Children's Society, and Prayer Meetings.

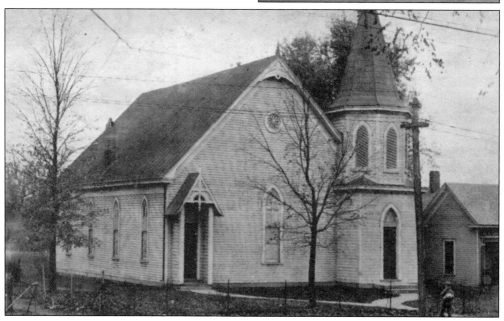

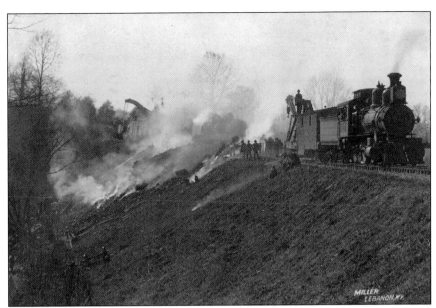

Train Wreck near New Hope, November 12, 1903. Six men were killed when two trains collided on the L&N Knoxville Branch near New Hope. A seventh man died of his injuries two days later. Both trains were fast freights and one was a "doubleheader," with two engines. Three huge locomotives and sixteen train cars were demolished. A fog had enveloped the two trains as they approached, and they were running at full speed on impact. When the two trains met, the crash could be heard for miles. Portions of the wreckage caught fire, which was followed by an explosion of dynamite that had been contained in two of the train cars. A dozen employees of the Belle of Nelson Distillery, located several hundred yards away, were among the first people on the scene. When they arrived, they could see that six heavily loaded gondola cars and ten boxcars had gone over a 30-foot embankment along with the engines. With the exception of a fireman who resided in Livingston, all of the men who perished lived in Lebanon Junction. This was one of the worst train disasters in Kentucky's history.

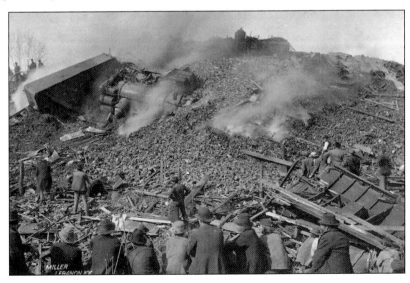

St. Vincent De Paul, New Hope, KY, c. 1910. This church was consecrated May 22, 1890. E.L. Miles and his wife Anna donated the main altar and the two main windows behind the altars. The side altars were donated by John and Gore Bowling. A newspaper account noted, "The windows are composed of Cathedral agate Venetian and a number of fine glasses with artistic and beautiful emblems. All donated by members of the congregation (Hagans, Bowlings, Mastersons, Berrys) except two which were the gift of Silvester Johnson of New Haven."

Boston Hotel, Boston, KY, c. 1904. A large and commodious frame structure with steam heat throughout, this hotel and saloon offered an excellent cuisine with the choicest wines, liquor, and beer. The proprietors, J.W. Crowe and Stephen Welsh, also ran a well-equipped adjoining grocery in which all forms of staples and provisions were sold.

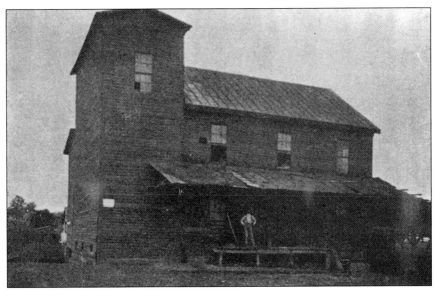

Boston Mill Co., Boston, KY, c. 1904. This mill was established in July 1902 by A.L. Harned, T.G. Harned, and W.S. Langsford. A.L. Harned became the sole owner in January 1904. This company transported and sold flour at towns on the Louisville and Springfield Railroad Branch, and from Louisville to London on the Knoxville line. The patent brands of flour for which they were widely known were Emma May, Best Pearl and 4X.

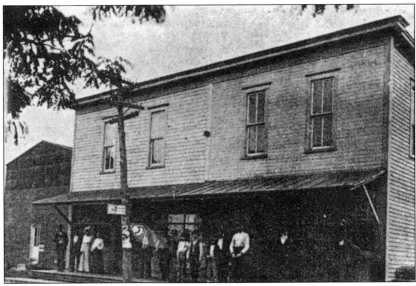

Boston Mercantile Co., Boston, KY, c. 1904. The largest mercantile company in Boston and surrounding vicinity, this business was owned and controlled by a stock company which was incorporated on February 1, 1901. Shown above are the main store and adjoining warehouse. The store contained two departments, one with dry goods, notions, and ladies' furnishings and the other a grocery and drug store. Also for sale were hardware, farm implements, and machinery, buggies, and wagons. Clothing, shoes, and hats were sold on the second floor.

Four

SPENCER COUNTY

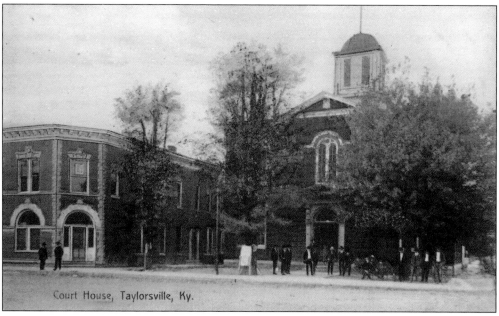

COURT HOUSE, TAYLORSVILLE, KY, *c.* **1909.** Spencer County was formed in 1824 from parts of Bullitt, Shelby, and Nelson Counties. It was named for Capt. Spears Spencer, who died in the Tippecanoe campaign in 1811. This courthouse was destroyed by fire in 1913 when many of the Main Street buildings were burned. Fortunately, all the records were saved. On the left is the People's Bank building, constructed in 1903. It was gutted in the 1913 fire and rebuilt to maintain its appearance.

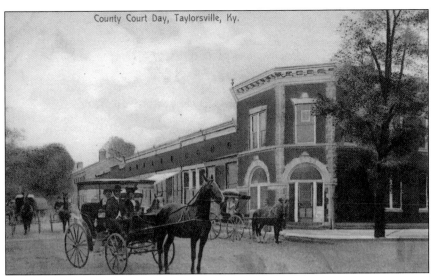

COUNTY COURT DAY, TAYLORSVILLE, KY, *c.* **1909.** The building with the two chimneys is the Spencer House, a 20-room hotel built in 1837. Isaiah Yocum was the proprietor from 1873-1925, when it served as a stopping place for stagecoaches and provided accommodations for traveling commercial salesmen who frequented small communities. In 1875, a stage line operated by Hughes and Shindler, was advertised "from Taylorsville to Louisville by way of Fairfield and Samuels Depot. It leaves Taylorsville at 2:00 AM and arrives in Louisville at 8:30 AM." A livery stable was located between the Spencer House and the business block. The corner building on the right is The Peoples Bank.

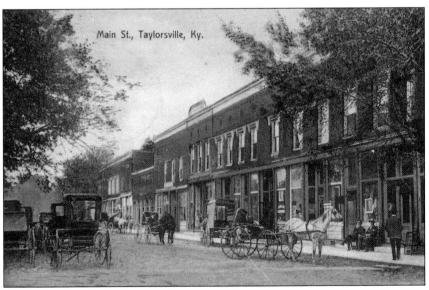

SOUTH SIDE OF MAIN STREET, TAYLORSVILLE, KY, *c.* **1909.** The buildings from the corner to Froman's Drug Store were constructed after the fire of 1898. The Barker, Wells & Buckner Undertaking Establishment was in the W.P. Beard building at right. Next is Tom Collier Drugs, then an empty building, then the office of *The Taylorsville Courier*, a millinery shop and furniture store, W.T. Froman Drug Company, then Charles Hough and Company Dry Goods, established in 1871.

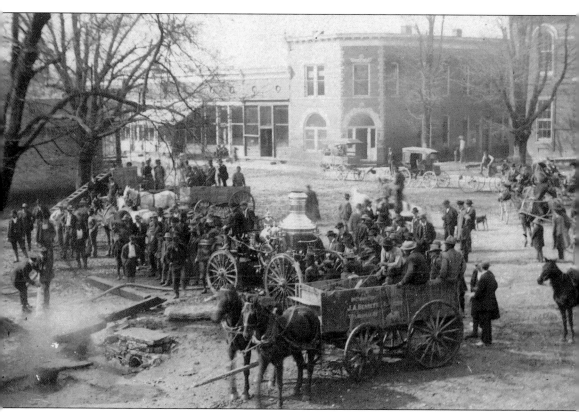

DEMONSTRATION OF FIRE ENGINE, *c.* **1909.** In 1874, James Albert Bennett started business in Taylorsville. First, he operated a livery stable and hotel, then a general livery sales business and later, sales of coal, lumber, seed, flour, lime, and salt. In the center of this view, his deliverymen have stopped to see a demonstration of a steam-powered fire engine fighting a fire. In the background from the left is a business block on west Main. The awning-covered store is a grocery, with a restaurant on the right and a jewelry store on the left. The Peoples Bank building and courthouse complete the block. All of these buildings were destroyed in the 1913 fire. The fire was fought unsuccessfully with a bucket brigade. The city organized a fire department shortly thereafter.

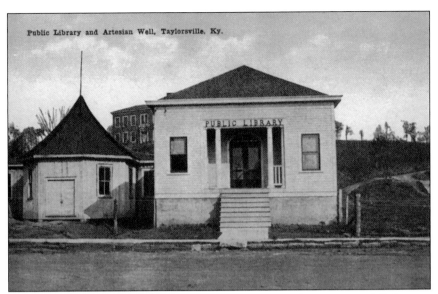

PUBLIC LIBRARY AND ARTESIAN WELL, TAYLORSVILLE, KY, *c.* **1912.** The Artesian Well Company was founded in 1905 for the purpose of boring a mineral well in the town of Taylorsville. The gazebo which formerly set atop the hill was brought down and enclosed and used to store the bottles for the water. The company committed to furnish Taylorsville with the water it might need for fire protection and the sprinkling of its streets. The public library was built in 1909 on land donated by Yoder Poignard on Main Cross Street. It was constructed by Ambassador Circle of the King's Daughters and Katie G. Mathes was the first librarian. The library closed in the 1920s.

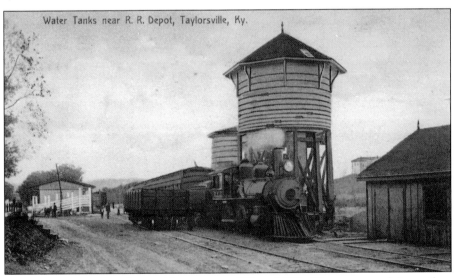

WATER TANKS NEAR THE R.R. DEPOT, TAYLORSVILLE, KY, *c.* **1909.** The water tank is on the west side of the track and the depot is on the east side. The L&N Railroad ran two trains daily between Shelbyville and Bloomfield. Agricultural products filled the outgoing freight cars and dairy farmers shipped milk daily. In 1916, the National Ice Cream Company operated an ice factory and creamery directly across the tracks from the depot. Train service was discontinued in the 1950s.

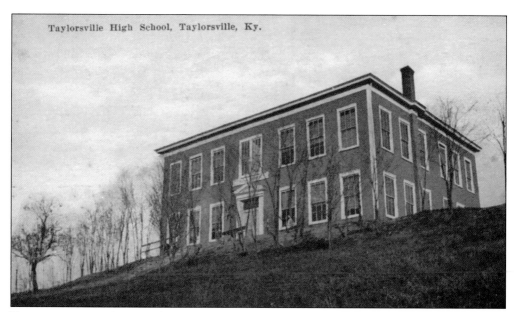

TAYLORSVILLE HIGH SCHOOL, TAYLORSVILLE, KY, c. 1909. In 1907, a new grade and high school was built on land donated by Yoder Poignard. He also contributed $2,000 toward the building's final cost of $8,860. In appreciation, it was named the Yoder Poignard School. The hill was formerly used as a park, with the open gazebo as a shelter. During the 1909 flood, 200 men, women, and children waded through waist-high water to seek shelter at the school.

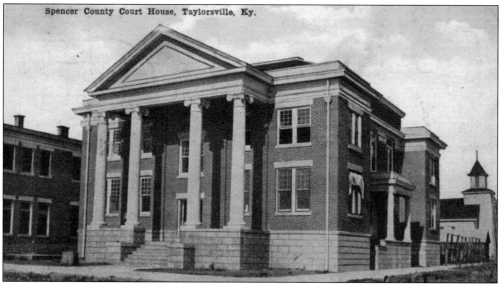

SPENCER COUNTY COURTHOUSE, TAYLORSVILLE, KY, c. 1920. This is the present courthouse, built in 1914, after fire destroyed the earlier building. A fire department was housed in a small building directly behind the reconstructed courthouse. By 1916, a volunteer fire department of 18 men and a chief was organized. It had two hose reels, 1,000 feet of hose, a 40-gallon chemical engine, a handdrawn hook and ladder truck with both 12-foot and 18-foot ladders and 36-foot extensions. On the right is the Christian church.

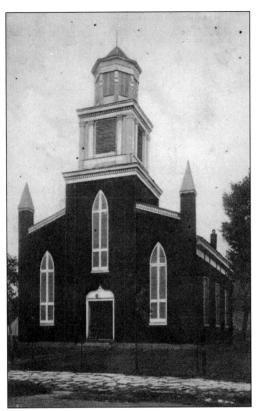

PRESBYTERIAN CHURCH, TAYLORSVILLE, KY, *c.* **1909.** This church is on the corner of Main and Jefferson Streets, but since has been converted to commercial use. The tower, corner spires, and windows have been removed and it is now only a shell. A diminished congregation travels to nearby churches.

FLOODED STREET *c.* **1906.** This is a view of Main Cross Street in 1906, one of the many times that Salt River overflowed. At the end of the street is the wooden covered bridge over Salt River on Bloomfield Road. The building on the right is the hotel operated in 1916 by Jack Eggen. The roof of McKenzie Mill is visible on the right. The last building on the left is W.H. Randall Wagon Shop. Between floods and fires, Taylorsville business buildings were constantly being repaired or rebuilt.

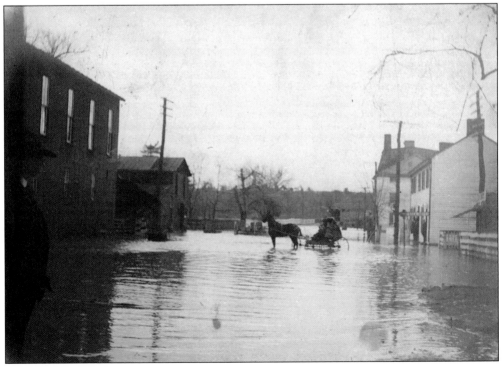

BAPTIST CHURCH, WEST MAIN STREET, C. 1912. The Baptists and Methodists shared a meeting house from 1841 to 1857. This church was built in 1858 under the leadership of Rev. Joseph Weaver at a cost of $5,200, which was paid off in six years. At this time, the church purchased the old Presbyterian church and gave it to their black members. In 1902, the cupola and the gallery were removed. In 1915, the entire church was demolished to build a new one. The memorial windows were saved for the new building.

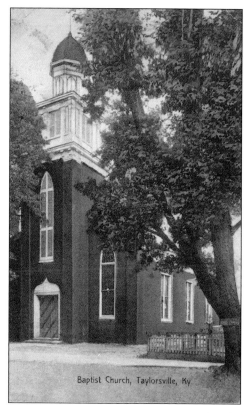

Baptist Church, Taylorsville, Ky

M.E. CHURCH, TAYLORSVILLE, KY, C. 1910. The Methodist-Episcopal church is located three lots west of the Baptist church on Main Street. The building, constructed shortly after the Civil War, is still in use, but the spire has been removed and the bell tower openings have been closed.

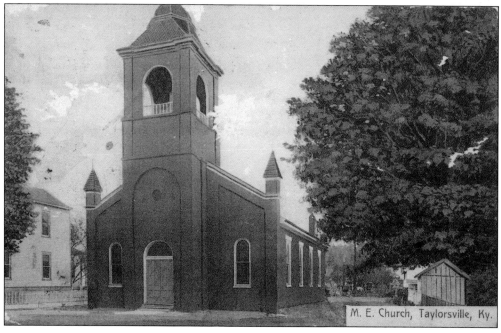

M. E. Church, Taylorsville, Ky.

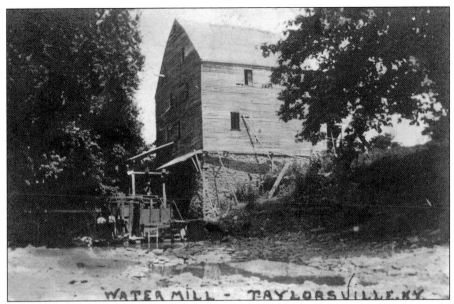

HENRY & SUTTON FLOUR MILL ALONG BRASHEAR CREEK, c. 1910. This mill had three sets of double rolls, a corn crusher, a bun and packer, and a scale on the first floor. On the second floor were wheat bins. On the third floor were eight elevators, two smut machines, nine bolting chests, and one branduster. Behind this building was the Beauchamp & Co. Saw and Planing Mill. These mills were no longer in operation in 1916 and the frame building collapsed in 1925.

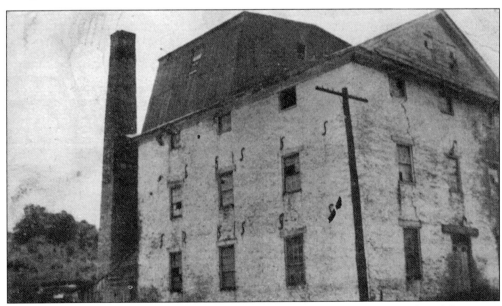

McKenzie Mill on Main Cross Street, c. 1909. An 1875 sale advertisement listed this steam flouring, carding, and grist mill for $3,600. It had a new boiler, two pair of wheat burrs, a pair of corn burrs, and two sets of cards. It was a three story brick building with barn and stable. Known as the Taylorsville Flouring Mills, it was bought in 1892 by James T. McKenzie for $5,000. It was operated until 1907 at Main Cross and Garrard Streets.

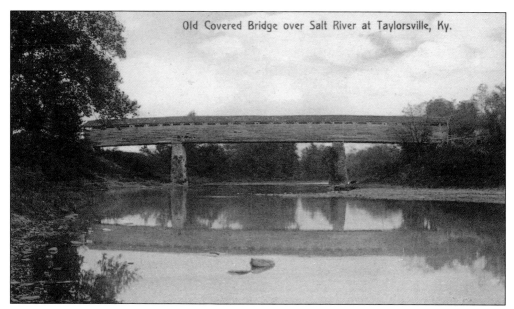

Old Covered Bridge over Salt River at Taylorsville, Ky.

WOODEN COVERED BRIDGE OVER SALT RIVER, c. 1912. This was the second bridge at this site. The first was built by George Bourne about 1830. In 1847, James Carothers of Bardstown was paid $850 to rebuild it. He was to ". . . lay timbers one foot wide and two inches thick of good sound white oak at least 15 feet long on the floor to make two runs for the wheels of wagons." This bridge was demolished after the metal span was opened upstream in the 1930s.

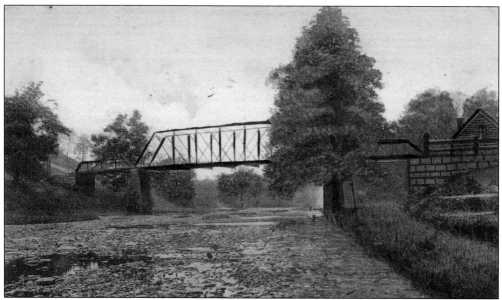

IRON BRIDGE OVER BRASHEAR'S CREEK, c. 1912. The iron bridge over Brashear's creek was built in 1879 and replaced a wooden covered bridge. It was purchased by the Spencer Fiscal Court from the Wrought Iron Bridge Company of Canton, OH, for $4,503.03. It served traffic until the present concrete bridge was opened.

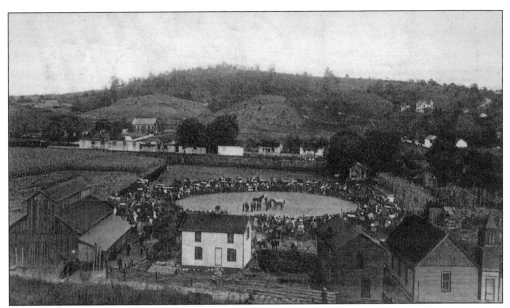

TAYLORSVILLE'S FIRST FAIR, 1908. The first fair was a successful, one-day event in October 1908. The fair was held on the land west of the railroad tracks next to the town. The buildings in the background are located along the tracks. In the lower right corner is the Minor Chapel A.M.E. Church on Jefferson Street.

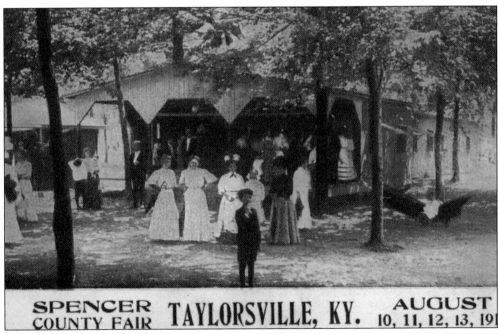

SPENCER COUNTY FAIR, 1910. After it was organized, the Spencer County Fair Association purchased land on the Louisville Road. A covered amphitheater, an enclosed floral hall, and horse barns were constructed. In 1909, Thursday's horse show and trotting race drew an attendance of 8,500. A "balloon ascension" was reported. The fair continued until the early 1930s.

Five

WASHINGTON COUNTY

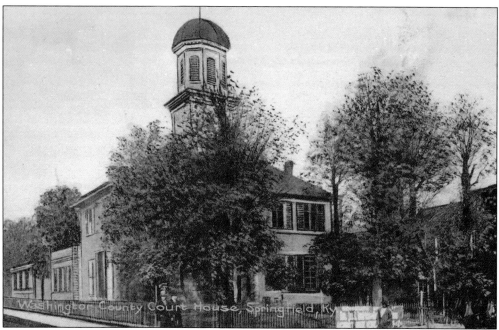

WASHINGTON COUNTY COURT HOUSE, c. 1915. Washington County was the first county formed in 1792 after Kentucky became a state. Springfield became the county seat. The first two courthouses were both destroyed by fire. This, the third courthouse, was designed and built by Thomas H. Letcher in 1816. In 1840, the cupola was added to the top. In July 1918, Nelson County architect Frank Brewer designed porches to be added to the front and side of the building. The court removed the iron fences that enclosed the front and side yards shortly thereafter. Some accounts say that the Marion County Courthouse, built in 1835, was a replica of this one.

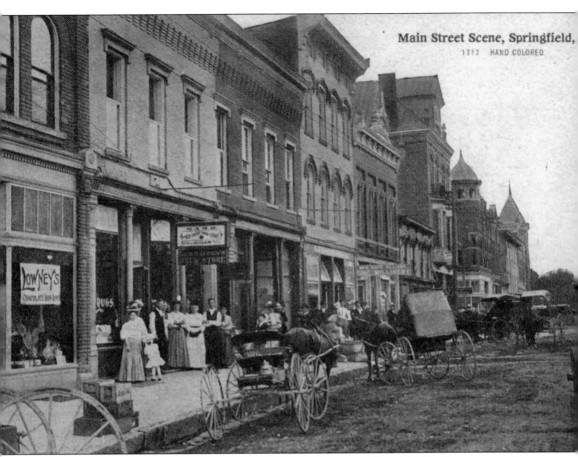

MAIN STREET SCENE, SPRINGFIELD, KY, *c.* **1909.** This is the first block of East Main Street, looking west. At left is the Confectionary and Bakery operated by Katie Hertlein & Bro. In 1909, the proprietors advertised that they have "installed the finest soda fountain in this section of the state. Soft drinks are kept ice cold by liquid air so that ice cubes won't dilute your drinks." The sign on the window notes "Lowney's Chocolate Bon Bons." Next door is the Leo Haydon Drugstore. The next business is unknown. In the three-story store building (with elevator) G.D. Robinson & Son General Store offered various goods for sale. The sign, "Kate Williams Fine Millinery," reveals where this successful business lady was operating in 1909. Later, this building housed the Majestic Theatre. The elegant facade of the Peoples Deposit Bank and the four-story Walton Hotel bracket a simple two-story building where a barber shop and meat market are located.

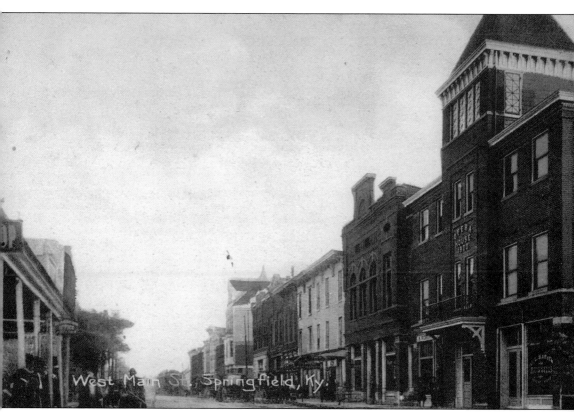

WEST MAIN STREET, SPRINGFIELD, KY, *c.* **1909.** On the left were located a barbershop, grocery stores, and the vacant lot where the Springfield Hotel stood before it burned. The opera house on the right, erected in 1900 by John R. Barber, was the center of cultural activities. Lectures, concerts, school recitations, plays, and traveling shows were performed here. The first floor had two business spaces. In the west space, a bowling alley operated until J. Rogers Gore established the *Springfield Sun* here in 1904. The Barber Hardware business moved there in 1924. Dadbury Furniture and Millinery store, and later a grocery, operated on the east side. Next door was the Masonic Hall, built in 1901, which was the location of the post office two years later. Continuing up the street, there were three businesses in the light-colored building: the Russell Jewelry store, a grocery, and a meat market. The First National Bank was next in the oldest building on the block, constructed in 1886. The G.L. Haydon Building, constructed in 1896, was used by Haydon & Barber Hardware and Groceries in 1903. The last building on the right is the W.K. Robertson Building built in 1896.

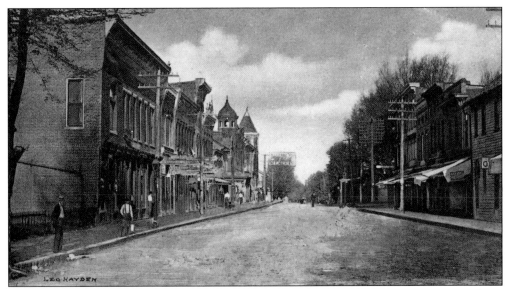

STREET SCENE, SPRINGFIELD, C. 1901. This view looks west from half a block east of the courthouse. On the right are the Adams Grocery and Restaurant, M.L. Searcy & Sons, a butcher shop, J.W. Mayes Furniture and Undertaker, and J.J. Mansfield Millinery. The last structure on the right is occupied by Grundy Claybrooke, ? McIntire, and Haydons Drugs. In the first building at left are McElroy & Shultz Hardware, J.C. Shader Grocery, and Cunningham & Duncan Dry Goods. The next building housed the Confectionary and Bakery of C. Hertlein. Wood & Campbell Drugs and P. Hagan & Son, a hardware and sundries business, shared a building. Robertson & Searcy Hardware and Grocery occupied the three-story building. In the 1909 view below is The Walton Hotel on the right. Next door in the two-story building were, at different times, the Adams Barber Shop, Price Saloon, Montgomery Restaurant, and Mulligan Meat Market. The Peoples Deposit Bank is in the next building. On the left was the "Corner Building" which housed Haydon Drugs, a billiards parlor, and a furniture store.

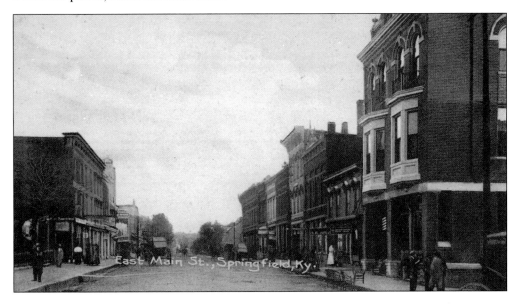

116

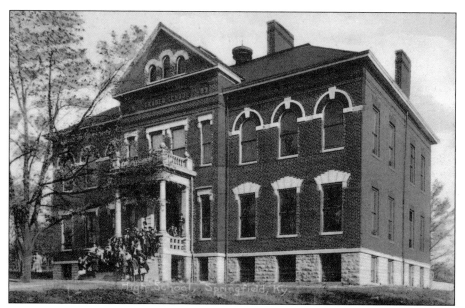

SPRINGFIELD HIGH SCHOOL, CORNER OF MAIN AND PERRYVILLE ROAD, *c.* **1909.** This building was erected in 1903 and used for both graded and high schools until 1924 when the new high school was erected. The new high school was described as having "... splendid classrooms with adjustable seats, a study hall, library, auditorium, and a gymnasium to seat about 700 people." This new school building burned in 1925. This structure is still in use as Washington County School Board offices.

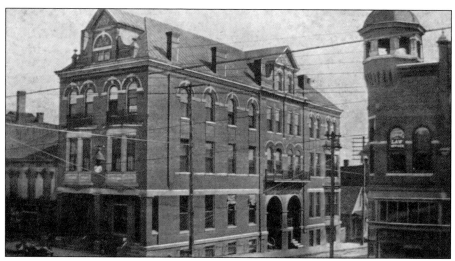

WALTON HOUSE, CORNER OF MAIN AND MAIN CROSS STREETS. *c.* **1920.** The Walton Hotel was built by John R. Barber in 1902, and named for General Matthew Walton, the founder of both Springfield and Washington County. It was completed in eight months at a cost of $20,000. It had twenty-nine sleeping rooms, two parlors, a dining room, a barbershop in the basement, house telephones, and steam heat. Built during the tobacco boom, it provided "big city" accommodations. When it was demolished in 1981, the headlines read, "Mose Polk is tearing down the Queen of Main Street." T.S. Mayes' law office sign appears on the second floor window of the W.K. Robertson building.

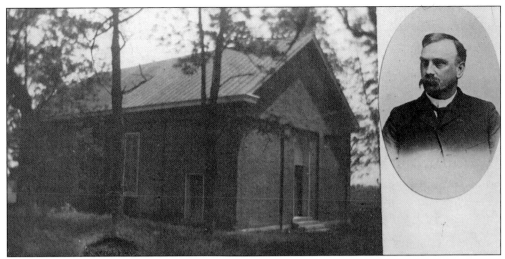

Bethlehem Baptist Church at Texas, KY, east of Springfield, c. 1908. This church was organized by Brother Ruben Padgett in 1805 with 34 members. Two earlier structures were used for worship before this brick building was constructed in 1860 at a cost of $300. It served as a house of worship until 1940 when it was destroyed by fire. Passing motorists warned those attending evening services of the fire, and they were able to save most of the church furnishings. Rev. R.L. Purdom is pictured above.

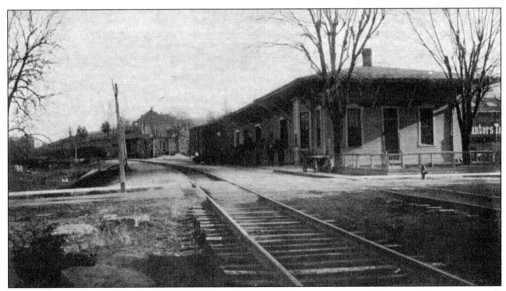

Springfield Railroad Station c. 1918. The L&N Railroad extended the Bardstown Branch line to Springfield by January 1888. A roundhouse allowed the engines to reverse directions at this end of the track. A newspaper article of June 1909 noted that L&N workmen were adding 20 feet to the east end of the freight room. This indicated a growth in the rail-shipping business. The train provided the main transportation to and from Bardstown and Louisville for both goods and passengers. The small communities along the track depended on the train for shipping agricultural products and all-weather traveling. Freight shipments of merchandise, coal, and machinery were vital to the area. The depot was dismantled in 1978.

BAPTIST CHURCH, MAIN STREET, *c.* **1900.** This church was located on the north side of Main Street, a few lots west of Doctor Street. The lot was purchased in 1889 and the building was erected soon afterward. It was dedicated in June 1892. A desire for a larger building caused the 1909 sale of the church building and the parsonage lots to G.C. Wharton. The congregation built a new church on the corner of High and Main Cross Streets, which they occupied in 1910. Later, this building was used as the Begemann Harness Factory. It has since been torn down.

NEW BAPTIST CHURCH, CORNER OF MAIN CROSS AND HIGH STREETS, *c.* **1909.** The new Baptist church was dedicated in 1910. The pastor, Dr. W.H. Williams, an architectural historian, was responsible for the gothic details. It was designed by a Louisville architect, Brinton Davis, and built by contractors Kreuger and Miller. Local merchant Joseph F. Pettus of Pettus Lumber furnished the materials at his cost and helped supervise the construction. The first service was held in the new church on December 19, 1909.

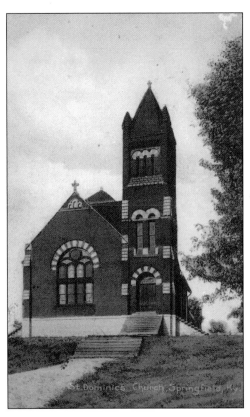

ST. DOMINIC CATHOLIC CHURCH, MAIN STREET, *c.* 1909. The cornerstone for this church was blessed by Bishop George McCloskey on November 13, 1890. A special excursion train was run from Louisville to Springfield for the occasion. The round trip fare of $2 included lunch. The congregation attended St. Rose Church, west of Springfield, before this building was constructed. In 1894, under the leadership of Father Joseph Hogarty, it was completed at a cost of $17,000.

INTERIOR OF ST. DOMINIC CATHOLIC CHURCH, *c.* 1912. This postcard was published by Haydon & Willett Druggists and postmarked 1912.

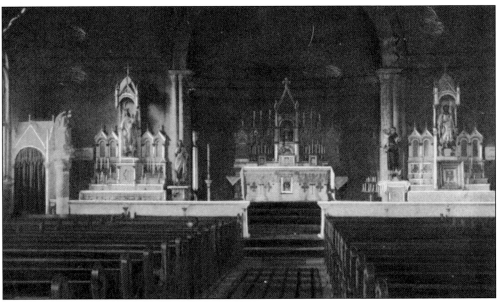

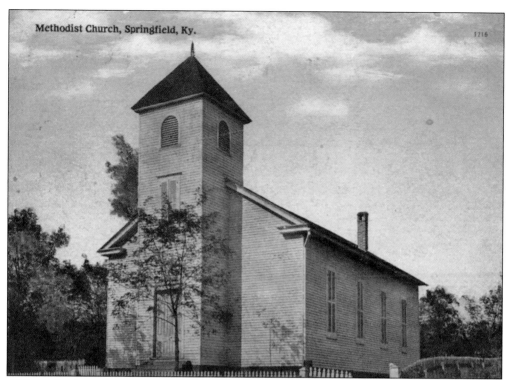

Old Methodist Church, Main Street, c. 1910. This view shows the Methodist church in Springfield shortly before it was torn down. It was estimated to be 93 years old at that time. When the congregation was searching for funds to build the modest frame building, they received a generous donation from a former minister of the church, Rev. Jesse Head. He is remembered as the man who married Thomas Lincoln and Nancy Hanks, parents of Abraham Lincoln, in this county, in 1806.

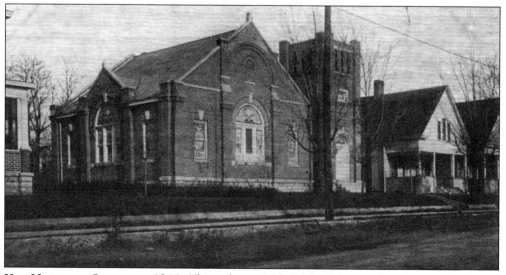

NEW METHODIST CHURCH, *c.* 1911. This substantial brick building replaced an earlier frame church on this same lot. It is still used today.

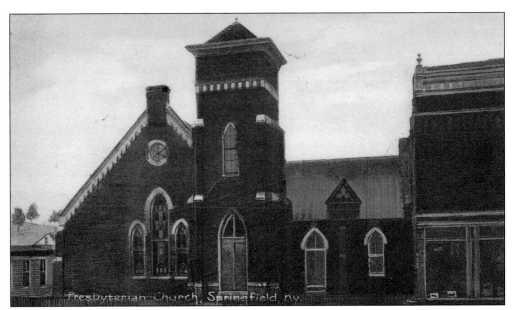

SPRINGFIELD PRESBYTERIAN CHURCH, MAIN STREET, c. 1909. Built in 1888, this church replaced an earlier church constructed in 1838. It had the same bell tower but was thirty feet higher than the one shown. Reverend Miles Saunders led the drive to construct a new building but determined to keep the original tower and attach it to the new structure. In 1942, it was painted red and later painted white. At present, it is the original red brick color.

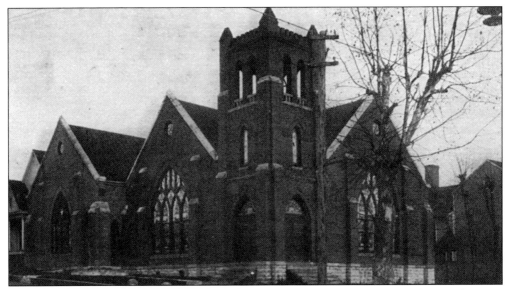

CHRISTIAN CHURCH, MAIN STREET, 1921. A gentleman attending a 1921 horse show in Springfield mailed this postcard. The Springfield Christian Church was first organized in 1898 with 51 members. After buying a lot in 1899, the congregation built this gothic style church in three stages. The first front section was constructed in 1900. The second section, consisting of an enlarged auditorium and eight Sunday school rooms, was completed in 1916 under the leadership of Rev. E.L. Mitchell. The Elias Davidson home is the building at right and is no longer standing.

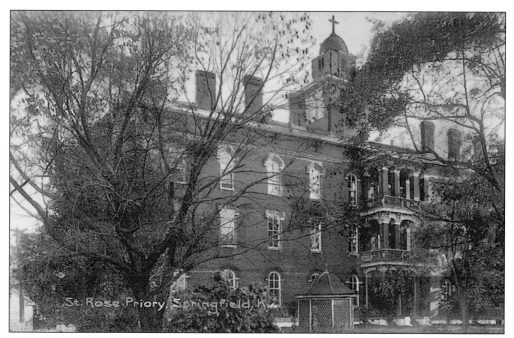

ST. ROSE PRIORY, WEST OF SPRINGFIELD, C. 1909. The original priory, built in 1808-1809, was founded by the Dominican fathers. It was the first secular college dedicated to St. Thomas Aquinas. An old school receipt book reads, "Jefferson Davis arrived at St. Thomas College at Springfield, July 10, 1816." The school received $65 for his tuition at that time. Later, on May 3, 1817, another payment of $50 was made on his behalf. St. Thomas ceased being a college after 1819 and operated as a seminary. The above four-story building was erected in 1867. Both the 1806 and 1867 structures were torn down in 1978.

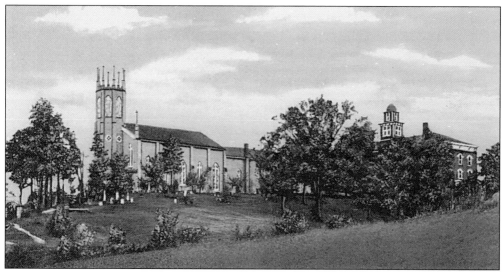

ST. ROSE CHURCH, C. 1909. The original brick church, built in 1809, was retained by Fr. Matthew O'Brien O.P. as the sanctuary when he enlarged the church in 1855. That allowed this church to be acknowledged as the oldest religious structure still standing west of the Alleghenies that was still used for worship.

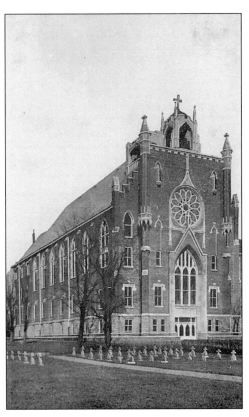

ST. CATHARINE OF SIENNA CONVENT AND CHAPEL, C. 1917. Maria Sansbury and eight companions answered the call of Father Samuel Wilson to dedicate their lives to Catholic education and formed St. Catharine Dominican Sisters in 1822. St. Mary Magdalen Academy was soon opened and thus began 148 years of primary and secondary education by this order. The sisters also cared for the sick during cholera epidemics in 1832 and 1851. After the Civil War battle at Perryville, October 8, 1862, the wounded soldiers were housed in the dormitories of the old academy building, which burned in 1904. The building pictured below was erected in 1905 to house the convent and academy. They continued the school until 1971. Today, the Sisters operate a two-year college founded in 1931 at this location.

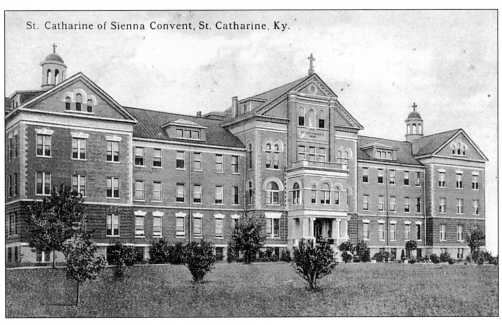

St. Catharine of Sienna Convent, St. Catharine, Ky.

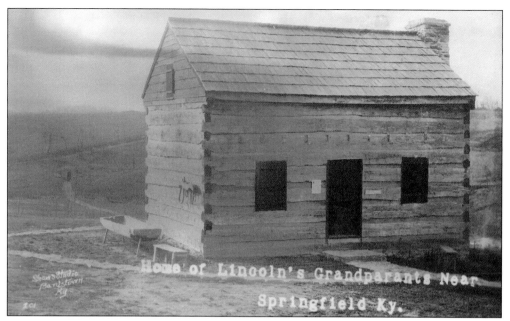

HOME OF LINCOLN'S GRANDPARENTS NEAR SPRINGFIELD, KY, *c.* **1920.** This is a replica of the cabin of Bersheba Lincoln, mother of Thomas Lincoln and grandmother of Abraham Lincoln, the President. Erected on their homestead land just west of Springfield, it resembles and represents her residence. Widowed by Native Americans in 1786, she continued to live nearby with her sons.

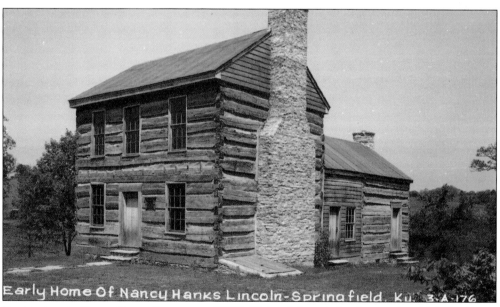

EARLY HOME OF NANCY HANKS LINCOLN, *c.* **1920.** Richard Berry's log home, in which the Berry family and Nancy Hanks lived during her courtship with Thomas Lincoln, was moved to and rebuilt at Lincoln Homestead State Park, near Springfield. They were married in Washington county on June 12, 1806, by Rev. Jesse Head, a Methodist minister. An 1859 statement said they were ". . . married in the home of Uncle Frank Berry."

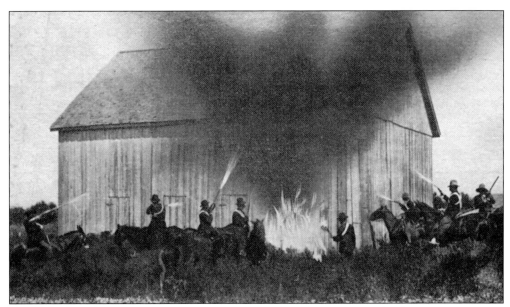

NIGHT RIDERS AT WORK BURNING BARNS, c. 1908. Night Riders in Kentucky, from 1905 to 1909, harassed local tobacco farmers who had not committed to reserve and sell their crop with the co-op. These hooded men on horseback threatened to visit "with switches and matches." In December 1907, a Law and Order League was formed in Washington County to protect the rights of farmers to sell where they wanted. Members promised to aid one another and prosecute people who threatened to whip a farmer or to dynamite his property. The movement to pool tobacco finally forced the American Tobacco Company and others to deal with organized farmers.

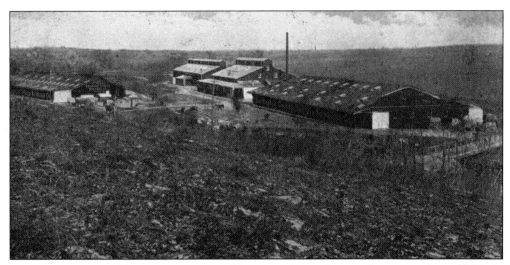

WASHINGTON COUNTY TOBACCO WAREHOUSE (ONE HALF MILE WEST OF COURTHOUSE), c. 1910. In 1908, Springfield was one of five loose-leaf tobacco markets in the state. The Washington County Tobacco Warehouse Company was created in 1907. One year later, the company had built two warehouses to handle tobacco sales. In 1909, the Farmers Loose Leaf Tobacco Company was organized and purchased land from the other company. The two buildings in the center are believed to be the two warehouses, which were erected in only two months.

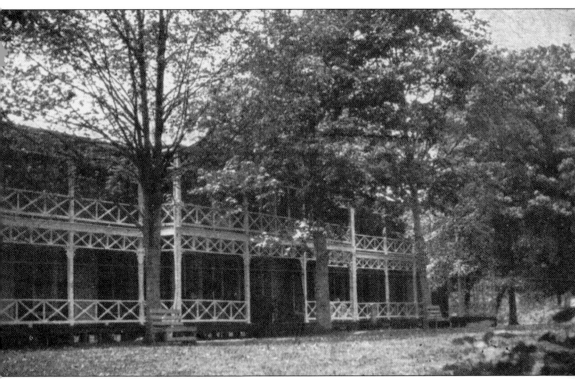

TATHAM SPRINGS HOTEL, *c.*1910. Tatham Springs Hotel was built in 1893 on Carey Island in the Chaplin River in Washington County. The river was dammed at this point to provide water power to a mill. The discovery of mineral water springs nearby generated interest in building a summer resort. Local investors built this hotel in which was located 40 rooms, a dining room, and a broad veranda. An advertisement stated that Mrs. James W. Wornall of San Francisco was the hotel manager, and that attractions included swimming in the mill pool, boating on the river, and nightly dancing. A 1909 newspaper account noted, "Dr. McCord was in such demand for a dancing partner that one evening he actually went to bed to escape the fair dancers who pursued him. The scheme failed as a bevy of pretty girls besieged his room and he was dragged out, in dressing gown and slippers, and made to dance until, like Cinderella, he lost his slipper." The water was advertised as a tonic: ". . . he needs go to Tatham Springs and he has taken a sip of the fountain of eternal youth." Three foot bridges crossed the river for those who liked to enjoy nature walks. Regular transportation by hacks from the railroad depots in Bloomfield, Springfield, and Lawrenceburg brought visitors from afar. Rates were $2 a day, $10 a week, and $40 a month. It flourished for more than 25 years, but the Depression and a lack of modernization closed it as a hotel in 1940. It was used as a 4H camp for many years afterward.

ACKNOWLEDGMENTS

We have chosen for this book only the rarest, most historic and, simply stated, the best postcards from the many available images—most previously unpublished—to tell the story of these five counties' rich past. Many of the images are from author, Carl Howell's extensive collection of pre-1930 Kentucky postcards; some are from author, Dixie Hibbs' collection; and a few others have been loaned to us from some of the individuals listed below.

A sincere expression of appreciation is extended to John L. Dennis and Steve Keith, who have enthusiastically opened their impressive postcard collections to us. The loan of several postcards from each of them, coupled with their encouragement and mutual desire to promote the early 20th century history of this area, have greatly benefited our endeavors.

Postcards, information and/or services have also been furnished by the following to whom we extend our gratitude: (from Bullitt County) Charley Long, Steve Masden, Tom Pack, Burlyn Pike, Lloyd Tichenor, and Stuart Tichenor; (from Marion County) Lynn Farris, Nash Hayes, Rose Marie Lee, Anna Pickerill, Linnie Raney, Theresa Rice, and Terry Ward; (from Nelson County) Louise Burns, Bill Coy, Rocco Dawson, Paul Hagan, Errol Johnson, Ed Kirkpatrick, and John Taylor; (from Spencer County) Tom Watson; (from Washington County) Mike Crain and Mary Jo McGuire. Non-area residents who have also furnished pictures, information and/or services to whom we extend our thanks include David W. Hayes, Ron W. Morgan, Josephine Stiles, and Tommy Turner.

In addition to personal interviews conducted with area residents, much of the research material from which information was obtained for this book was found in period newspapers and on microfilm, the John W. Muir archives, and the Sisters of Charity of Nazareth archives.

We also extend our profound gratitude to Janice Donan, whose computer expertise and services allowed us to meet our publisher's deadline.